# ABANDONED
# ARKANSAS

# ABANDONED ARKANSAS

## AN ECHO FROM THE PAST

MICHAEL SCHWARZ, EDDY SISSON, GINGER BECK, AND JAMES KIRKENDALL

America Through Time is an imprint of Fonthill Media LLC
www.through-time.com
office@through-time.com

Published by Arcadia Publishing by arrangement with Fonthill Media LLC
For all general information, please contact Arcadia Publishing:
Telephone: 843-853-2070
Fax: 843-853-0044
E-mail: sales@arcadiapublishing.com
For customer service and orders:
Toll-Free 1-888-313-2665

www.arcadiapublishing.com

First published 2019

Copyright © Michael Schwarz, Eddy Sisson, Ginger Beck, and James Kirkendall 2019

ISBN 978-1-63499-097-4

All rights reserved. No part of this publication may be reproduced, stored in a retrieval system or transmitted in any form or by any means, electronic, mechanical, photocopying, recording or otherwise, without prior permission in writing from Fonthill Media LLC

Typeset in Trade Gothic 10pt on 15pt
Printed and bound in England

# CONTENTS

About the Authors   **7**

1   **REMEMBERING MAJESTIC**   **9**
    By Michael Schwarz

2   **A DOGPATCH JOURNEY**   **35**
    By Eddy Sisson

3   **A NEW ADVENTURE IS ALWAYS WAITING**   **62**
    By Ginger Beck

4   **THE NEGOTIATOR**   **88**
    By James Kirkendall

    Epilogue   **109**

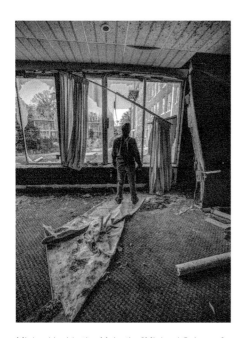 

Michael inside the Majestic *[Michael Schwarz]*   Eddy Sisson at Dogpatch USA *[Eddy Sisson]*

# ABOUT THE AUTHORS

### MICHAEL SCHWARZ

In January 2012, Michael saw a television newscast reporting an abandoned building on fire. This building, Dunjee High School, was a place Michael had visited before. That same day, he went to the school to photograph the remaining ruins of the building. There he met the widow of the former principal of the school. Her story evoked strong emotions in Michael, because, through her tears, she revealed this building was the last tangible memory which remained of her husband. This story changed Michael's perspective of abandoned buildings. He realized they weren't just buildings, but places that hold history and valuable memories for many people.

### EDDY SISSON

Eddy Sisson joined Abandoned Arkansas in 2013 and was so moved by the locations that he has since volunteered tirelessly to help restore life to Dogpatch USA and other locations. His group "Arkansas History Rescue" adds life to forgotten and abandoned properties.

Ginger Beck *[Ginger Beck]*  James Kirkendall *[James Kirkendall]*

## GINGER BECK

Ginger Beck has been curious about the unknown, particularly the abandoned, since her early childhood. Her imagination would often take over good sense, and it still does to this day. That adventurous nature has helped her grow as an urban explorer, a writer, and a tattoo artist. She travels as much as she can but never struggles to find adventure in her back yard. At thirty-nine, she still hopes to one day be an astronaut or at least dig up some Tyrannosaurus bones. Find her on Instagram @highfiveg.

## JAMES KIRKENDALL

James Kirkendall is a Fort Smith resident and joined the Abandoned Arkansas team in 2014. He owns two dogs, a parrot, and lives with his wife, Ashleigh. Though he struggles with a learning disability, his talents and persistence have led him to an array of different achievements. Some of the greatest feats have been receiving a black belt in traditional karate and performing overseas in the Fringe Theatre Festival in Edinburgh, Scotland. His education includes several computer technology certifications and he has attended the New York Film Academy in LA. His interests include video games, roller skating, and martial arts.

# 1

## REMEMBERING MAJESTIC
By Michael Schwarz

Have you ever found an old, torn-up book and hesitated before throwing it out? Have you ever found a two-dollar bill, but didn't want to spend it? For some people, it's easy to throw out the old, but for others, not so much. Why is it we want to hold on to things? Is it that your mother gave it to you on your tenth birthday? Is it because it reminds you where you first met your girlfriend? When I was young, I remember my mom saying, "One man's trash is another man's treasure." For some reason, that phrase has stuck with me.

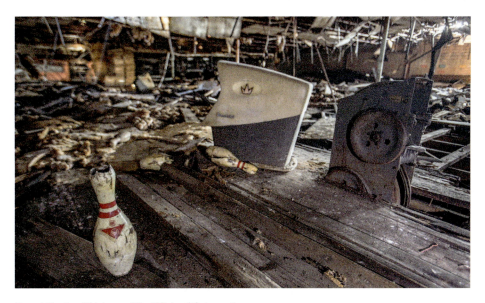

Bryant Center, Oklahoma City *[Michael Schwarz]*

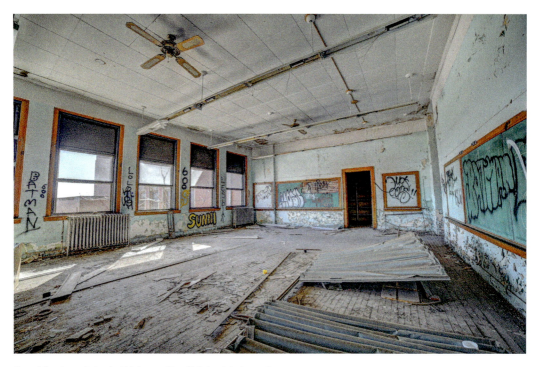

Page Woodsen School, Oklahoma City *[Michael Schwarz]*

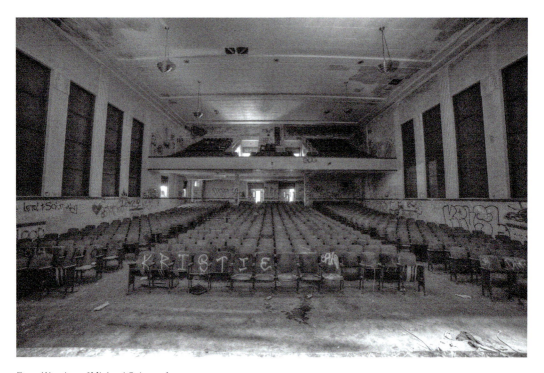

Page Woodson *[Michael Schwarz]*

As I was growing up in Oklahoma City, I had almost forgotten what my mom said. And I'm not going to lie, I was probably what you would have considered your average high school kid. I wasn't particularly interested in anything and didn't really know what I wanted to do. However, I would make amateur action movies with my friends because they were fun, and I was bored on most weekends. Looking back, some of them were slightly more graphic than I realized. That's how you get the neighbors to call your parents. But that's how I spent most of my time until one of my friends mentioned there was an abandoned circus in the middle of a neighborhood. She said it would be perfect for one of my little videos. I went to check the place out with my buddy, Alex, and we stayed for over five hours. This was beyond anything I have ever seen. There was an old bus, circus trailers, animal cages, and I even found a ticket for one of their shows dated 1963. To this day, I wish I would've kept that ticket because I never found it again. After that, I was hooked. I stayed up all night researching other abandoned places around where I lived because it fascinated me how people can leave behind these landmarks and traditions.

For instance, Townley's Dairy, located on the outskirts of Oklahoma City, was the number one dairy provider for central Oklahoma beginning in the 1940s. After the last manager, Robert C. Townley, died, the family sold the company to another popular dairy provider, "Hiland Dairy," located in the southern area of the state.

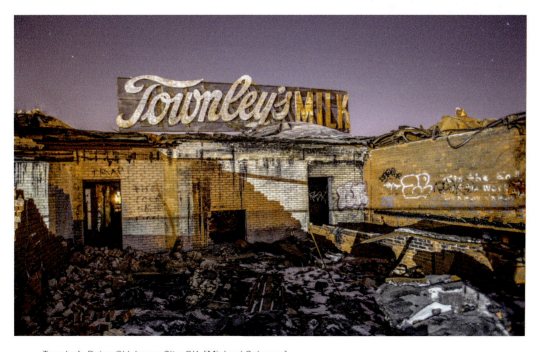

Townley's Dairy, Oklahoma City, OK *[Michael Schwarz]*

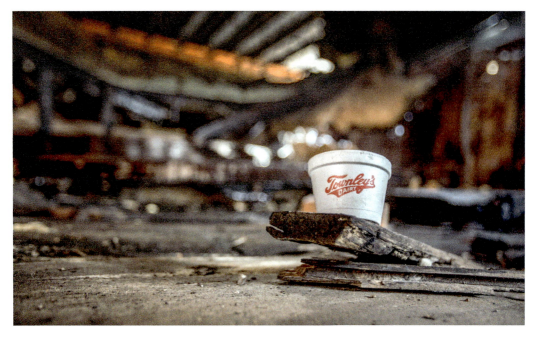

Townley's Dairy, Oklahoma City, OK [Michael Schwarz]

As for Townley's dairy, it now sits in complete darkness, abandoned, with no one seeming to care whether or not it even exists.

There was one special school which really caught my eye. The old Dunjee High School in Spencer, Oklahoma.

When the school closed, everything was left behind. There were books, desks, and even assignments on the chalkboards. I traveled back to that school at least twenty times trying to figure out the story hidden in the walls of this school. Each time I was there, I walked through the empty halls feeling as if the school bell was going to ring and all the students would exit the classrooms. Yet, as I stood there, I knew school was out, but no one was ever coming back.

Buildings like this were left abandoned, broken down, and forgotten. There are schools, hospitals, houses, amusement parks, factories, and bowling alleys, just to name a few. I've been exploring old, abandoned buildings for about six years now and people often tell me they drive by these places and wonder: What's inside? What happened there? So, what causes these buildings to end up like this? Is it just money? Are they not relevant anymore? Maybe aliens? Whatever it was, over the next few years, I made it my mission to explore and photograph every abandoned structure I could find before graduating high school. I ended up exploring around 300 places and found myself dragging lots of friends along to these adventures, and to this day I don't know if they even really wanted to go.

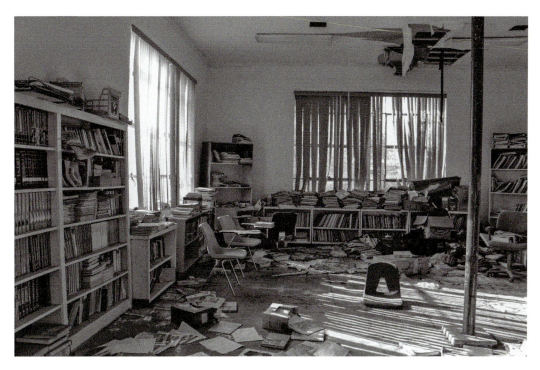

Dunjee School, Oklahoma City, OK *[Michael Schwarz]*

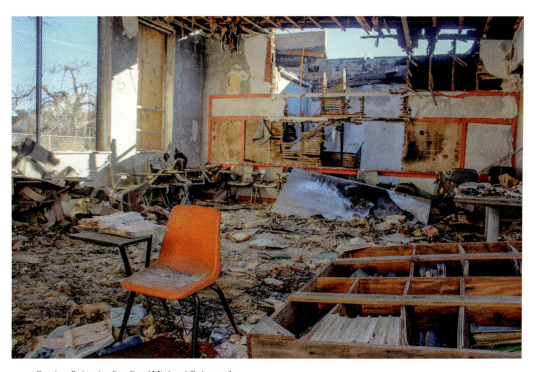

Dunjee School, after fire *[Michael Schwarz]*

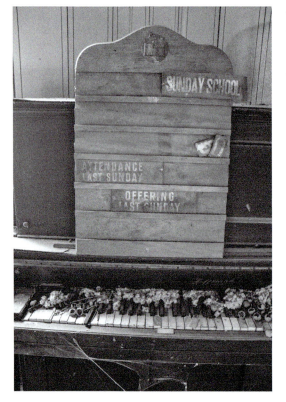

*Above:* Dunjee School, after fire
[Michael Schwarz]

*Left:* Red Hill Community Church, Marshall, AR
[Michael Schwarz]

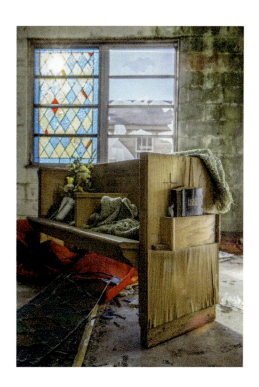

Gloryland Fellowship Family Church, North Little Rock, AR [Michael Schwarz]

Around the time I was ready to graduate, I decided to get a degree in digital filmmaking and was accepted into college in Arkansas. It was a five-hour drive from where I grew up, and this was my first time living on my own and not knowing anyone where I was headed. So, what did I do when I got there? Go out and socialize? Heck, no. I googled abandoned buildings in Arkansas. And weirdly enough, there weren't many results. It took a little digging, but I found an old hospital in Little Rock. When I arrived, the building was undergoing demolition and I photographed as much of it as I could.

As I was leaving, I noticed there was a large church with broken windows with a sign that read "Gloryland Family Fellowship Church." The doors were open, and as I peeked inside, I found it was clearly abandoned. After photographing these places, I debated whether or not to upload them to my Facebook page. I thought people might be getting tired of seeing abandoned photos on their newsfeed. Instead, I decided to start a page entitled "Abandoned Arkansas." Over the next year and a half, I met people on campus and others who messaged me through the page, and I found my group of exploring buddies. I made it into a website as well, and it seemed that we were finding new places to explore every week. Well, not really "new," but you know what I mean. My mom's saying, "One man's trash is another man's treasure," finally had meaning—I had truly discovered my treasures.

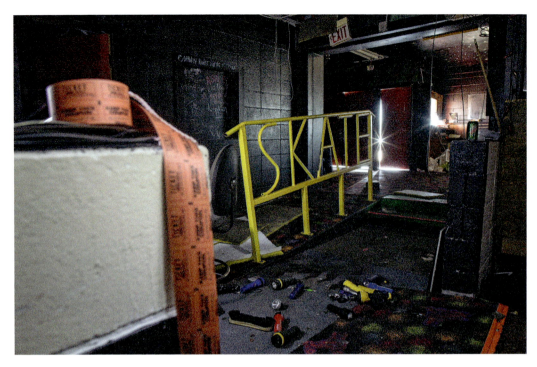

Conway Roller Rink, Conway, AR *[Michael Schwarz]*

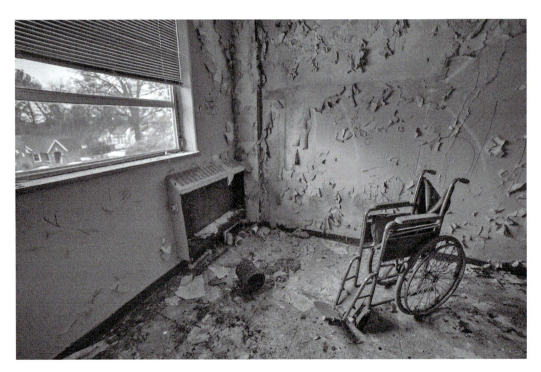

Saint Joseph's Hospital, Brinkley, AR *[Michael Schwarz]*

The page and website grew. We had 2,000 likes and were getting around fifty to sixty website views a day. I was surprised at how many people were taking an interest in these old buildings. We were getting comments every day from people who grew up in the area and had stories and memories they wanted to share.

These comments had me thinking: I wonder if any of these places ever get renovated. I mean, why not? They have a history and lots of people who care about them. So why not give them a second chance. I would love to see them renovated and would help in any way I could if the opportunity came up. That's when I found my ultimate treasure—it was the chalice of all treasure that could be found. It was known as the Majestic Hotel. Closed, then abandoned in 2006, this building sat in the middle of a quiet little town called Hot Springs, Arkansas. Not only did this hotel have a fascinating history, but it turns out the city did as well. My life was about get very interesting.

Hot Springs had a population of about 40,000 people and about twenty abandoned buildings, primarily in the historic downtown. It was most famous for its healing thermal bathhouses. When the healing waters were discovered, Hot Springs started seeing tourists from all over America. Hotels were popping up left and right. The Arlington, the Eastman, the Baxter, and of course, the Majestic.

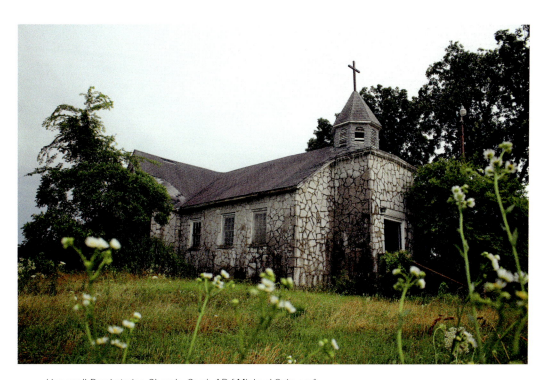

Hopewell Presbyterian Church, Cord, AR [*Michael Schwarz*]

1925 Column, hidden by glass since the 60s (Majestic Hotel) *[Michael Schwarz]*

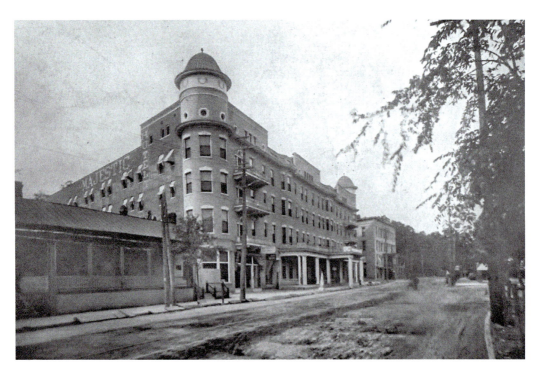
Yellow brick building, 1905 (Majestic Hotel) *[Unknown]*

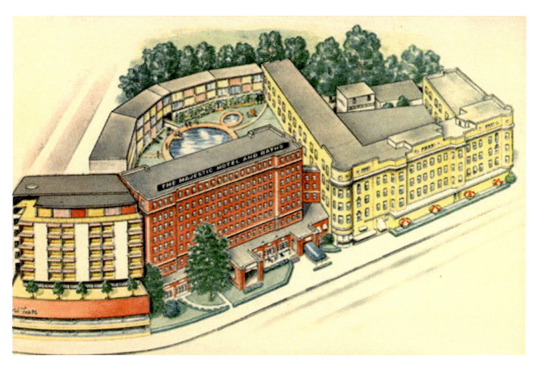

Postcard, 1971 (Majestic Hotel) *[Unknown]*

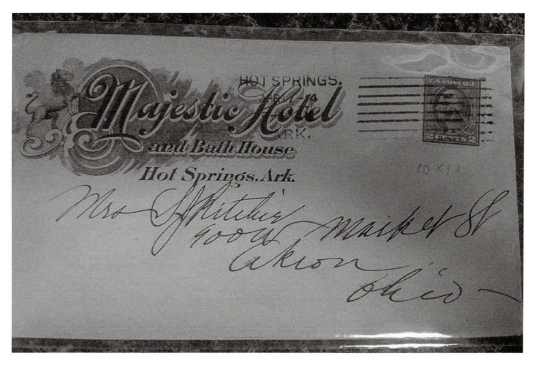

Majestic letter (Majestic Hotel) *[Unknown]*

Hot Springs was thriving like no other city in the state until gangster activity in Hot Springs came to an end in the 1960s, due to a federal crackdown. The city started losing money and was slowly starting to wither.

Downtown Hot Springs saw the closure and demolition of many casinos, hotels, clubs, and the five famous and extravagant bathhouses which were so popular in past years. Many businesses tried keeping afloat by adding on and introducing new features and attractions. However, by the 1990s, downtown was dead. Unfortunately, the Majestic Hotel was one of the buildings that met that fate.

When I first stepped into the now abandoned Majestic Hotel, I couldn't believe what I was seeing. It had already been abandoned for six years. Furniture, fixtures, dishes, and all the uniforms were still left in the building. I had never seen anything like it. It was a gigantic building in the middle of an historic district. How did it become abandoned? Why was it just left? Were there plans to renovate it? These are the questions I asked myself in 2012 as I walked down the hall, smelling mold and looking at the peeling paint and empty rooms.

I kept finding myself returning to this place and taking picture after picture. There was just something about this place, and I could feel it was dying.

That's when I met Brenda Brandenburg, a nurse in Hot Springs Arkansas, who had a similar passion for this building, but for another reason. As a young girl, Brenda's father played in a band at the Majestic and she would help him carry his drum set into the back entrance of the hotel. Because of her frequent visits, she knew the entire staff at the Majestic. In 2012, businesses in the Downtown area were doing well, buildings were being refurbished, and the downtown area was becoming popular again. So why was something once so grand, and visited by so many famous people including Al Capone and Babe Ruth (just to name a few), just being neglected?

Brenda and I talked for hours about the possibility of renovating this place and we decided right then and there to start looking for investors. I had never seen anyone as passionate about a building as Brenda, and I was glad to see that others were finally starting to care. On February 27, 2014, Brenda was talking with an investor from France who was very interested in purchasing the property for renovation. This was it—this was our chance to finally save the Majestic. And that's when it happened. A fire was set in the oldest part of the Majestic.

That night, I drove down to Hot Springs in record time, and stood dumbfounded as I watched my favorite building turn into den of ash. How could this have happened just as the windows of opportunity were opening up for this beautiful building? It seemed like 1,000 people were gathered outside watching as the Majestic burned. Everyone stood in silence. It felt as if people were just waiting, waiting for the fire

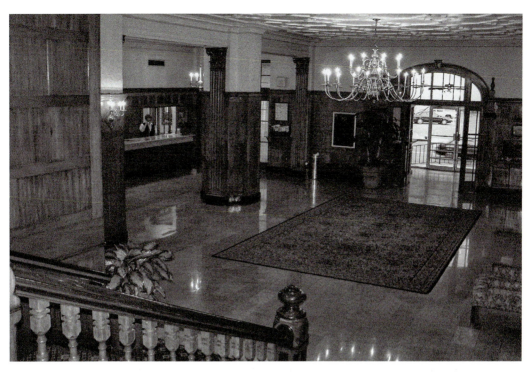

Lobby before (Majestic Hotel) *[Lisa Wolfe Goodwin]*

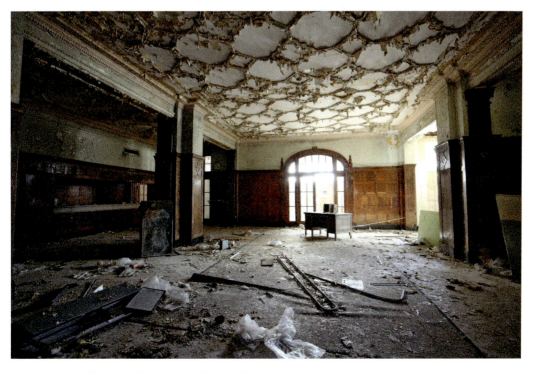

Lobby after (Majestic Hotel) *[Michael Schwarz]*

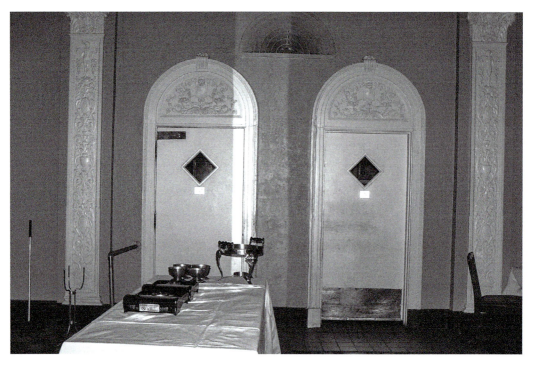
Veranda Room before abandonment (Majestic Hotel) *[Lisa Wolfe Goodwin]*

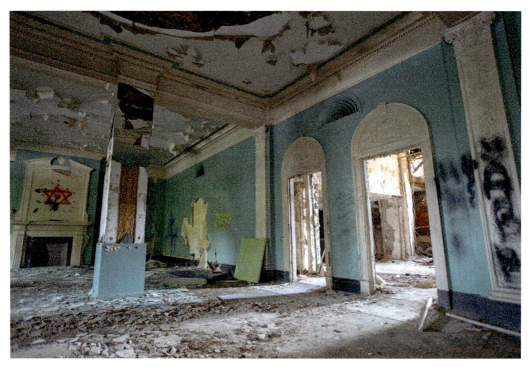
Veranda Room after abandonment (Majestic Hotel) *[Michael Schwarz]*

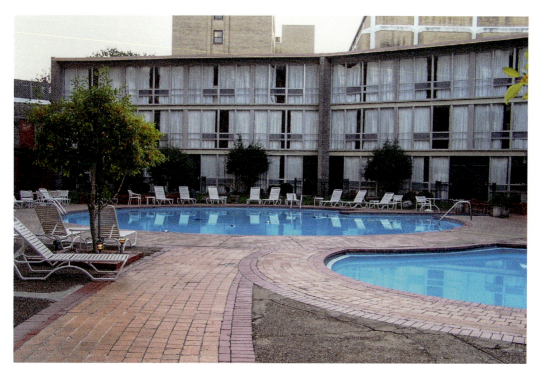

Pool area before (Majestic Hotel) *[Lisa Wolfe Goodwin]*

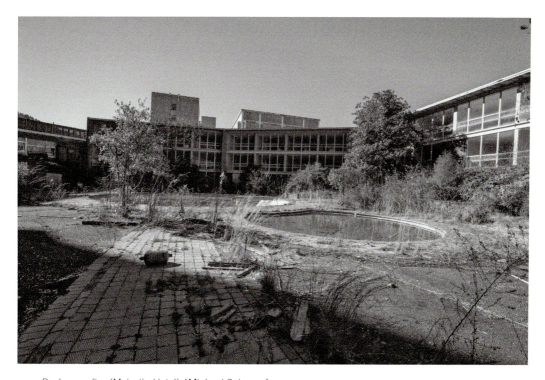

Pool area after (Majestic Hotel) *[Michael Schwarz]*

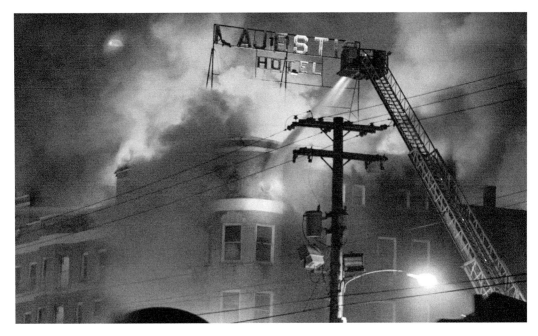
Majestic Hotel on fire, Hot Springs, AR *[Michael Schwarz]*

to be put out, and for the building to go back to the way it was. But in reality, we all knew that wasn't going to happen.

The next morning, the fire was out, but the inside of the building looked like an overcooked marshmallow. That's when the demolition crew was called. The oldest part of the Majestic Hotel was torn down, leaving behind a pile of rubble and a hole in the sky.

The next week of school was one of the longest of my life. I flunked two tests and didn't do any homework. Four nights in a row, the Majestic Hotel flooded my dreams. The image that is still burned into my head is of me walking on a pile of rubble and seeing an old woman begging for help underneath a pile of bricks. I yell out for help and everyone passing by seemed to tell me, "She's a goner," "Just leave her," and "Don't waste your time." It was obvious to me that the Majestic was the old woman. Many people around Hot Springs were ready to see the building demolished, even though many of them had their own connections to the building.

After the 1902 yellow brick building of the Majestic burned, there were still three sections of the building that remained. But unfortunately, they didn't have long. It crushed me inside that all I could do was stand by and watch. Brenda and I attended many board meetings and even started a petition to try and save the rest of the dying building. In August 2016, they finally came. Demolition crews brought in all their fancy equipment to take apart and strip away something that once held the town together.

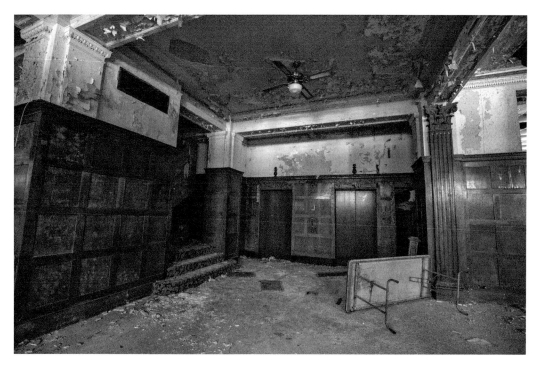
Lobby elevators (Majestic Hotel) *[Michael Schwarz]*

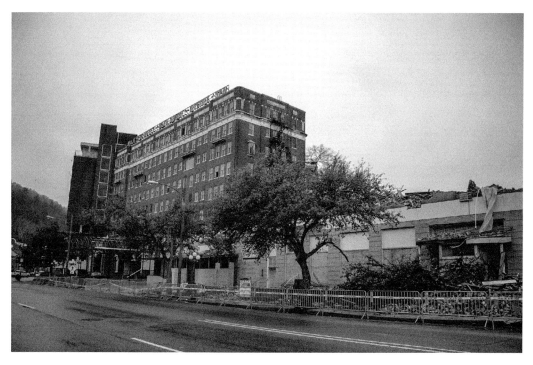
Yellow brick building, February 2014 *[Michael Schwarz]*

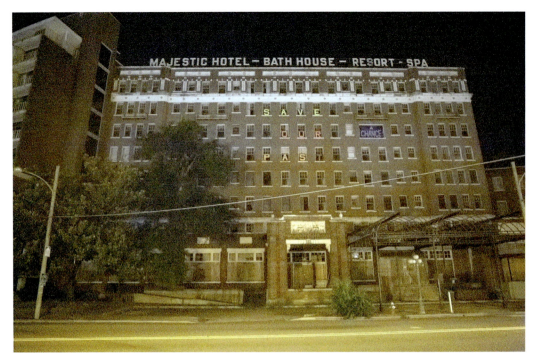

"Save or Past" sign posted in hopes to stop the demolition (Majestic Hotel) *[Michael Schwarz]*

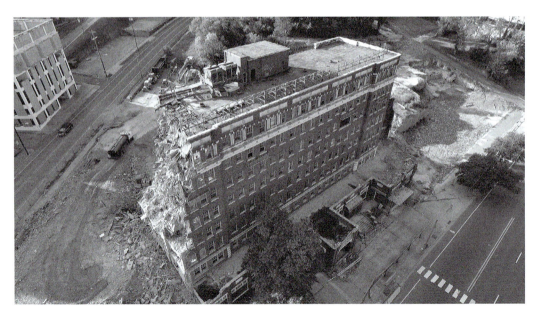

Red brick demolition (Majestic Hotel) *[Michael Schwarz]*

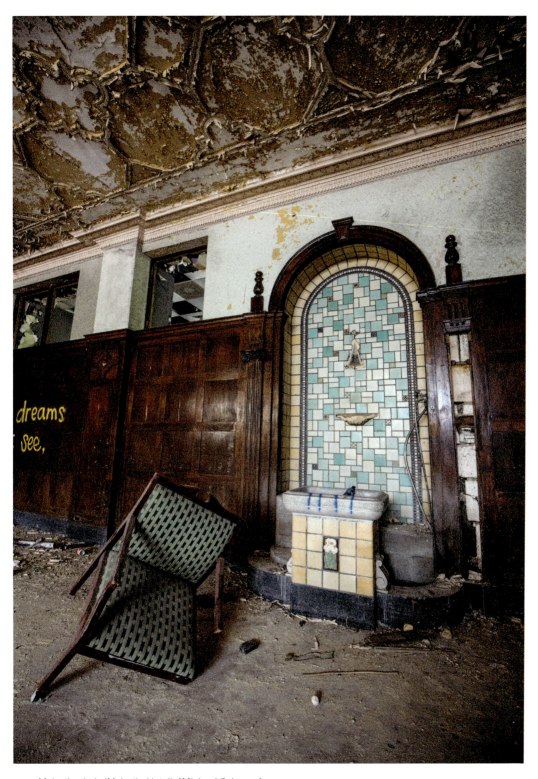

Majestic chair (Majestic Hotel) [*Michael Schwarz*]

By November, it was all gone. If you go to the site today, you can find some bricks, some metal pieces and even some of the original flooring from the bathhouse and hotel lobby from the yellow brick building. But you'll mostly find grass. As of right now, the city has no plans with the property, but Brenda is still fighting for something just as "majestic" to go in this place. In March 2018, a little over four years after the fire, she and her fiancé, Wally, opened a gluten-free bakery called the Majestic Bakery and Café. It sits right across the street from the now empty property.

To this day, I still don't fully understand why I grew such an attachment to this building. I mean, I had no reason to. I think what I mostly noticed was the passion that other people had for this place. While seventy percent of the town didn't give a second look to the "eyesore," there were people that cared enough to stand up to the city, to the naysayers, and even to people that were close to them. After the demolition of the Majestic, I moved away from Arkansas. I moved out to California, to pursue my career in digital filmmaking. But not a day goes by that I don't think about what happened in that town. I only can hope that some of the other historic abandoned buildings can be preserved or saved in some way.

So, why is it we hold onto things? Is it a feeling of nostalgia? Or is it more than that? Now that I'm in California, I have a whole new territory to explore. Maybe I will find a new Majestic that can be saved. One day, I will hopefully have the answer, but until then, I will keep exploring.

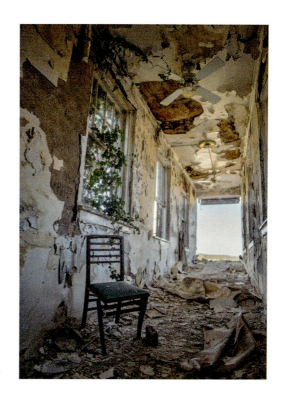

Open hallway (Majestic Hotel) *[Michael Schwarz]*

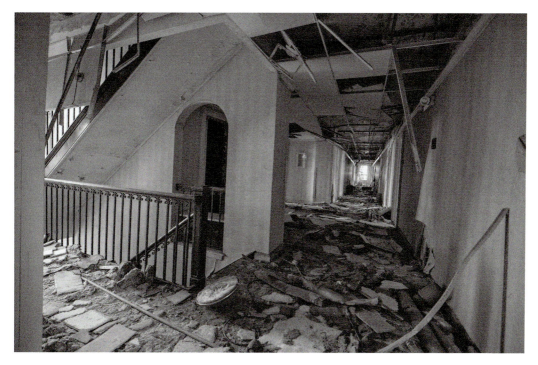

Red brick hallway (Majestic Hotel) *[Michael Schwarz]*

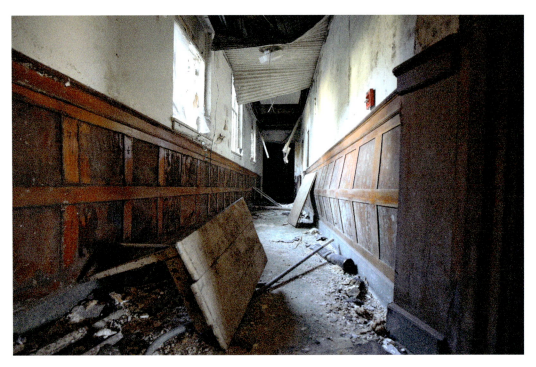

Hallway to yellow brick *[Michael Schwarz]*

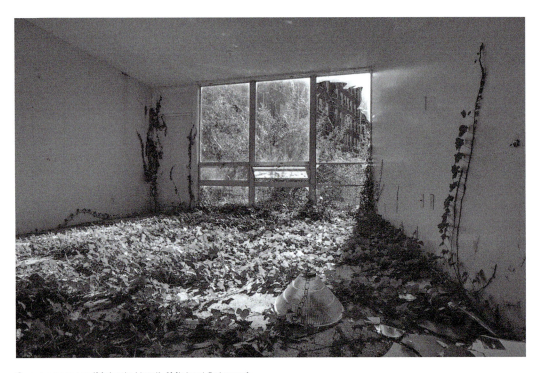

Overgrown room (Majestic Hotel) *[Michael Schwarz]*

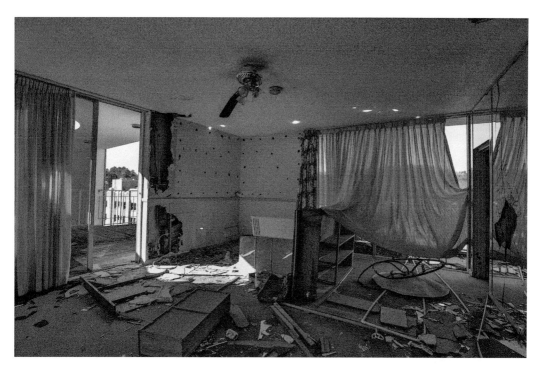

Penthouse (Majestic Hotel) *[Michael Schwarz]*

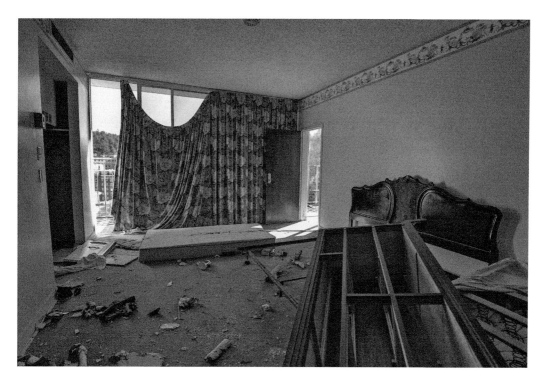

Honeymoon Suite (Majestic Hotel) *[Michael Schwarz]*

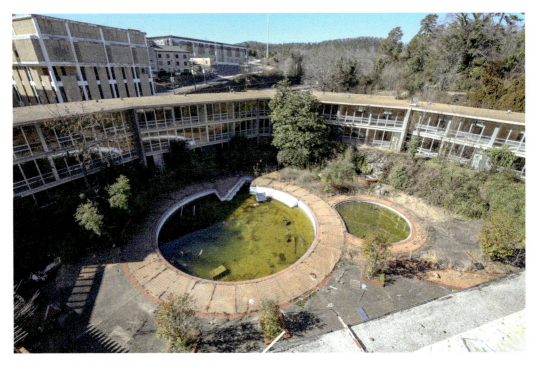

Pool view (Majestic Hotel) [*Michael Schwarz*]

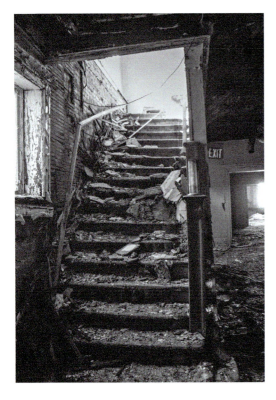

Staircase (Majestic Hotel) [*Michael Schwarz*]

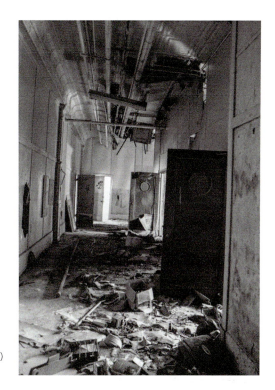

Doorways in maintenance section (Majestic Hotel)
*[Michael Schwarz]*

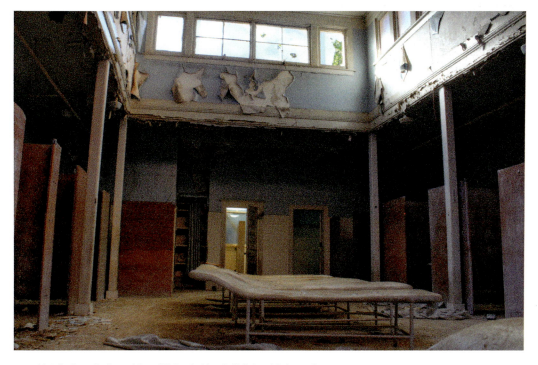

Hot Springs Bath and Spa (Majestic Hotel) *[Michael Schwarz]*

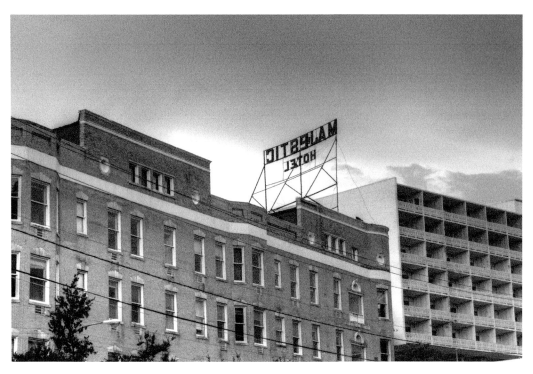
Yellow brick building, January 2014 (Majestic Hotel) *[Michael Schwarz]*

# 2

# A DOGPATCH JOURNEY
By Eddy Sisson

When I was a small boy, the home I grew up in was right next door to six abandoned houses. They were moved from the main highway to my street due to the city pressuring the building's owner to get them off the main highway. I remember them originally scaring me—I was afraid to walk past them after dark. Once I got older, I explored them several times and my love for forgotten places began (though video games and comics won me over more as I grew older, and I wouldn't think about abandoned places for a long time after).

Eddy on top of "Wild Water Rampage" *[Michael Schwarz]*

Fast forward to 2011—I was an overnight auditor at a hotel, and needless to say, the job was boring. My mind wandered often, and I remembered exploring those houses so long ago. They had been destroyed in a planned burn many years before, but I thought there had to be other places just like them. Or maybe something even better, perhaps? I hopped online to search for other locations that might be interesting to look at that were in the state. It was then I fell in love.

The results of my search led me to a very tall, rickety looking waterslide in what looked to be in an overgrown field. My eyes popped out looking at the photo, seeing the weeds growing almost half of its height and vines wrapping around, climbing all the way to the top. It was literally quite amazing. How had this happened? Why was it still there? There were so many questions and I had to find out more.

Dogpatch USA 1970 (Schmoo Character) *[Unknown]*

Dogpatch 1975 *[Susan Johnson]*

Dogpatch was a theme park that operated from 1968 to 1993. The theme was Al Capp's "Lil' Aber," a hillbilly yet very political comic. Before Dogpatch was built, the land belonged to Albert Rainey and his trout farm, which sold to O. J. Snow and REI Enterprises, who would develop it into an amusement park. Before even that, the area was actually a small town called Marble City. The park was very profitable up until the late 70s. It was at that time Jess Odom, the owner of the park, decided to take the park's earnings and build a ski resort on top of the hill above Dogpatch, calling it Marble Falls Ski Resort. For a time, both "MFSR" and Dogpatch were dubbed "The Twin Parks." It was short lived. When the ski resort failed due to a multitude of reasons and closed, Dogpatch itself filed for bankruptcy soon after in 1980. The park would limp along for a little over a decade longer until 1993, even booking big name talent such as movie stars and headlining national musical acts throughout the 1980s.

In the end, many factors attributed to Dogpatch's downfall. Hillbilly culture popularized by television shows like *The Beverly Hillbillies* became a quick passing fad. Al Capp stopped drawing Lil' Abner and over time younger people simply didn't know who these characters running around in the park were. But mostly, the park just could not recover from the bankruptcy of 1980 and nothing could stop the dwindling attendance no matter who owned it or what they tried.

Dogpatch 1975 *[Susan Johnson]*

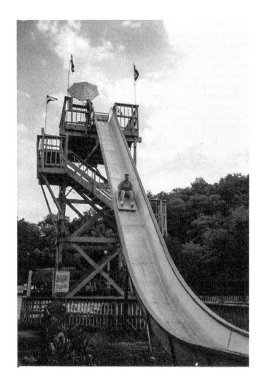

Dogpatch 1975 *[Susan Johnson]*

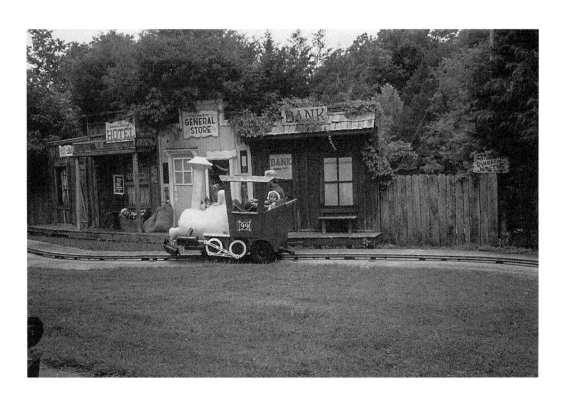

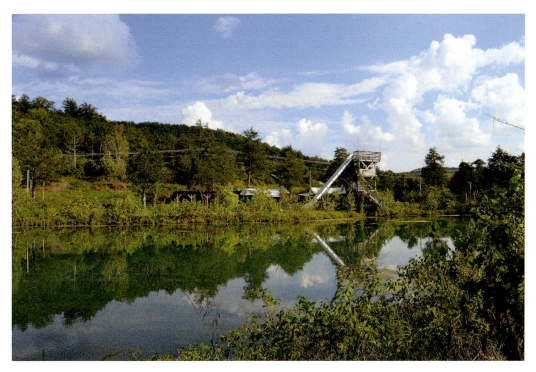

Dogpatch Pond *[Eddy Sisson]*

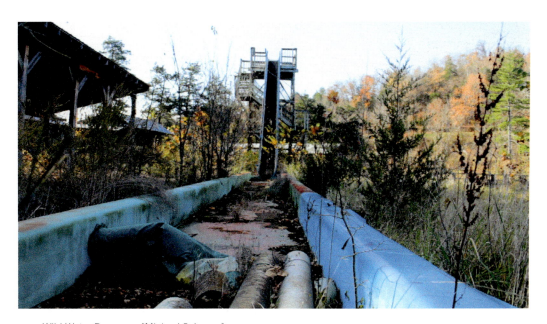

Wild Water Rampage *[Michael Schwarz]*

Once Dogpatch closed in 1993, the large rides were sold to other parks, leaving the immovable funicular trams and immobile waterslide, which of as this writing, are still frozen in place thirty years later. Literally everything else remained—costumes, signs, employee records, and memories. The wooden fence surrounding it would eventually fall, inviting thieves and trespassers, who in the next twenty-five years would vandalize and steal from its structures, leaving nothing but a skeleton behind.

When I found images of the park online, they excited me in a way I hadn't experienced. I explored the land via Google Earth, learning the layout of the structures and pathways. I dug up as much history as I could find. Believe it or not, back then there wasn't too much out there on the internet as far as history was concerned. I found about thirty historical photos and a few sites with photos years post-closure along with a blog post about the history of Marble Falls.

Nevertheless, I was about to become obsessed by this mysterious abandoned wonderland.

However, I realized I had missed something. I had forgotten about Facebook! Everything has a page on Facebook. People make hundreds of pages for celebrities and all kinds of nonsensical things, so surely someone had made a page for Dogpatch. Unfortunately, much like the rest of the internet, Dogpatch wasn't represented there either. Along with its physical presence, its history and memories

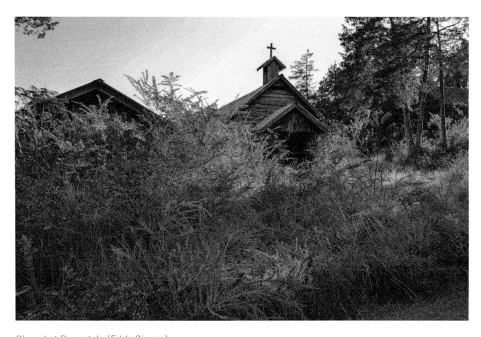

Chapel at Dogpatch [Eddy Sisson]

were also being forgotten. Thus, I made a page on Facebook called Dogpatch USA. Why not? This way I could potentially learn more about this magical place as people submitted photos and commented. And that's exactly what happened.

The page started growing. People sent photos and I reposted them. I reached out and asked people to use their post-closure photos so that I had a good mix of "in operation" and "abandoned" images. As people shared my posts, the page grew more followers. As a result, people would comment and tell about their memories or just say that they missed the park. It was this way I slowly learned what each building was used for and the deep history of the area. Although the original images of the park all grown up with vines and weeds initially grabbed me and made me fall in love, it was the people's memories and stories that they told, either in a comment or simply in the photo, that made me go from seeing the park as "cool" to sad. I had already felt its voice inside my heart: "Help me."

Some time went by and my obsession grew. I would routinely search for new photos every week for the page. One night I found a set of new images, this time from a group called Abandoned Arkansas. It was quite the set! I remember being enthralled by the originality of the shots, especially of the waterslide.

It was the first shot I had seen from the very top of the slide as someone in the group was brave and/or stupid to climb the thirty-year-old tower. At this time the

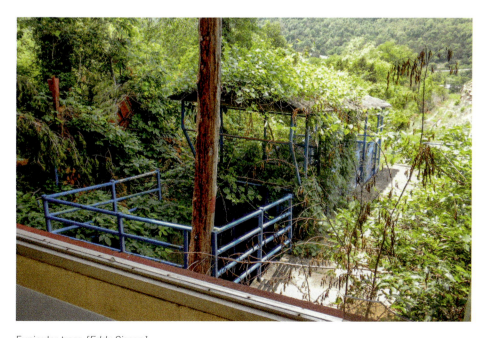

Funicular tram *[Eddy Sisson]*

Busted sign *[Michael Schwarz]*

Dogpatch page had roughly 8-10,000 followers. When I checked out Abandoned Arkansas, it didn't hold a candle to what the Dogpatch page had amassed so far. So I sent a message to them asking if I could use their images and give full credit, which would bring some much needed traffic to their page. A friendly guy named Michael Schwarz replied and agreed. We talked a bit about the park and the page I had created for it. He liked the idea of letting me promote his page on mine and I couldn't wait to get his photos out there to a wider audience. It was a win/win situation. The deal generated well over a thousand new followers to Abandoned Arkansas and Michael and I made another deal—if he ever went back to the park, he'd take me along next time.

Months followed and every now and then Michael and I would talk through Facebook. I was really liking him. He offered to let me go on an abandoned excursion; to be honest, I didn't really want to do anything other than visit Dogpatch but thought that maybe if I did this, it would speed up the process. We met on a scorching summer day in 2013 for a trip to Hot Springs to see the Majestic Hotel, Mountainaire Hotel, and a couple of other spots. I didn't know what to expect, but Michael was super nice and had a very goofy and non-confrontational attitude. We became fast friends and, unknowingly at the time, over the coming years he would become a brother.

As fall approached, I went on a number of adventures with Michael and the AAR crew. I was having fun tapping into that forgotten part of my youth again exploring forgotten places, but nothing was moving me emotionally. I enjoyed the journeys, but Dogpatch was still waiting. I reminded him that we should go and to my surprise he had the owner's number on his phone. The owner at the time had no problem with us visiting the property as long as we signed waivers of liability. Was this really happening? Was I finally going to see Dogpatch USA?

We set a weekend trip up for November of 2013. We would stay there on top of the hill in the former Marble Falls Resort Hotel that the park once used, but was now called The Hub, now turned into a motorcycle themed hotel. The days couldn't go by fast enough. We would be there for the entire weekend. That's two full days of exploring this mysterious abandoned property and I was beside myself. I was going to be able to take my own photos and post them to the Dogpatch page. At this point, I had unofficially become a part of Abandoned Arkansas and we were going to document the entire trip for both pages.

In November, the day finally came. Michael and I hit the road, traveling down scenic Highway #7 from Russellville to Jasper. The fall weather made the trip simply beautiful. With the gorgeous array of brown and orange, the entire trip was beyond belief. So beautiful, in fact, at a certain point near Jasper I literally gasped, losing my breath in the

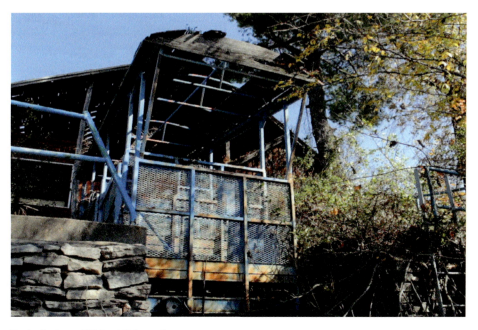

Funicular tram *[Michael Schwarz]*

scenery. Once we passed Jasper, I knew Dogpatch was near and I was getting super excited. I couldn't wait until I saw it with my own eyes and experienced its wonder for myself. We finally rounded the curve and saw the first building. But something strange suddenly happened. As we passed the park to the hotel, my excitement waned and my heart dropped. Utter sadness gripped me like I have never felt before.

You could see a few structures, but most were surrounded in weeds and vines. It looked worse than in any photos I had seen. Cool, right? Normally, yes, but something was different. There was a deep sorrow in the air as if a looming cloud of despair hung over the village of the park. There was no time to worry about that though, as we were at the hotel already and had to get our clothes and equipment out of the car.

Since we got there semi-late in the afternoon, we checked in quickly and started to head toward the park. Michael wanted to drive to the first building, the red tram building, which was basically a giant gift shop and housed the funicular trams that took visitors from the top of the hill to the actual park below, but I wanted to walk the lot to take it all in. Michael left and I began my journey. This was it. I felt engulfed by the huge parking lot with the sole building looming in the distance. Just emptiness. There even were people living on top of the hill where we were, but there was an overwhelming feeling of solitude and sadness, despite being populated with a hotel/restaurant and a few houses. It was at this point that I realized I was really there. I was finally at Dogpatch USA.

After the lengthy trek across the parking lot, I met Michael at the building, its red paint faded by the sunlight. The metal on its roof was coming unhinged and was slamming with the wind that I would later discover would always be blowing on the hill. All of its windows were smashed and gone years ago. It was definitely an area most people have explored and vandalized. We found Terry Boswell's (THE creative genius behind many things in the park) office and the old wall safe in the offices in the back. To this day, I wonder what, if anything, is in that safe. I personally don't feel like actual money is in there, but I want to believe a lot of vintage merchandise just might be. Or it could be completely empty. I also wonder how many more years it will be until someone can get inside to find out. As far as I know it hasn't been opened since 1993. The most interesting room was the wheelhouse. The park had funicular trams made in Sweden and shipped there in the late sixties. Before that, patrons were bussed down.

 I would be lying if I told you I knew how the wheels and machines operated. The thick, metal cord was still connected from the tram to the wheelhouse inside all those years later. The tram car was suspended in place after its last tour up the hill, frozen in time, looking down on the park it will never return to again. We ditched Michael's car and walked down the tram tracks which were perfectly preserved despite small trees growing up in the middle of them. The wonder of the park lay

Train bridge *[Eddy Sisson]*

below and ... the waterslide! But it would be getting dark soon and we had to make haste if we wanted to see a lot of the park. When we got to the bottom of the tracks there was the other tram car. This one was in much better shape. One car would bring the guests into the park and one would take them back to the parking lot. The tracks split in the middle, allowing both cars to pass each other.

Michael said that we wouldn't be able to see everything that day, so we decided to split the park up in sections. To my dismay, the slide would have to wait until the next day, as the trout farm area would be all that we would be able to visit as the sun started its slow descent into the horizon. We saw the famous "Dogpatch Univercity" building, where trained animals from ducks to bears performed, the trout hatchery, and the former home of the Rainey family. The petting zoo was across the creek, but was so grown up it didn't look worth it, and the bridge was in terrible condition. After we checked out the trout farm area of the park and before it got too dark, we walked back up the tracks (which was exhausting) to the car where the motel room awaited.

That night, I could hardly sleep. The majority of the park and its coolest features I would experience the next day. I think I got only a few hours, and as soon as the sun came up, we headed back down.

That next day, we saw everything: the town square with all the buildings and cabins, the train station, the famous Kornvention Hall stage that Three Dog Night and many others played on, the kissing rocks, Big Red Razorback statue, the train trestle and tunnel, and the old waterslide, the "Wild Water Rampage." It was much

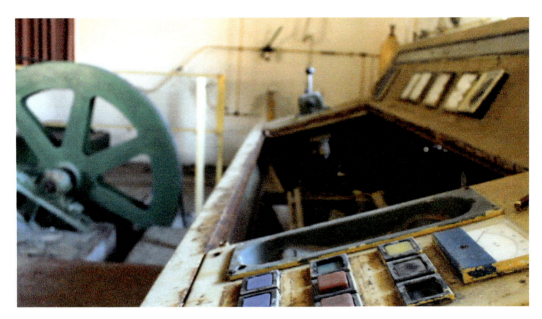

Tram mechanical board *[Michael Schwarz]*

larger in person than it appeared in photographs. I'll admit I was nervous to climb to the top, but I figured it would be my only chance, so we went up.

Surprisingly it was a lot sturdier than I thought it would be. The view from the top was incredible, and we both took our time and captured a few shots. In historical photos, there would be a huge umbrella for protection from the sun for an employee who had to run the ride. There was no umbrella anymore—however, the bracket which held it remained frozen in stasis, still there after all those years.

The park was surprisingly free of graffiti. Windows were busted and holes in walls were plenty, but these transgressors at least had the decency not to completely deface Dogpatch's history. We actually met a few trespassers while we were there, but they were just photographers and no one was looking to destroy anything. I was already in protect mode and figured I'd berate someone if I saw anything happening I didn't like.

We hit the old Dogpatch Jamboree barn and witnessed the stage where many local country artists performed. There was the chapel and a few manual carousels for kids, and I found three bathroom buildings. I was actually on a quest to locate all the bathrooms. As the story goes, when the park was built in 1968, it did not have restrooms and guests were reported relieving themselves wherever they could. Bathrooms were constructed in 1969 after health officials stepped in. I just found it strange and interesting and made it a personal mission while I was there to locate them. I found four sets that weekend and some were so hidden that I wouldn't even find all six until November 2017!

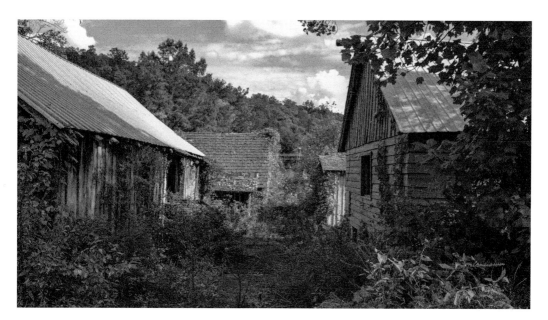

Downtown Dogpatch *[Eddy Sisson]*

There was also the building that once housed the miniature cars for the "Antique Auto Drive," the waterfall, and more shops on the other end of the park. It was a lot to take in. The day was over and ended just as fast as it had begun. It was a truly magical experience to have an entire abandoned theme park to yourself. As we drove off, I promised it that one day I'd come back with a different purpose.

After we headed home, I continued to go to different locations with Michael. But by March, I was itching to go back to Dogpatch, and this time I wanted a three-day trip. Luckily for me, Michael was just as excited to do it again as well. We went back for three days in March 2014 along with a couple others, and again stayed at The Hub. I actually went up early on Friday and invited my sister to join me. She had a blast and as the day was wrapping up, Michael and the crew met me. It was just as magical as the first time, except cold. Really cold. I had a sold three days of exploration wandering the park. When Sunday came around, I still didn't want to leave. But all good things must come to an end, and I figured that this would probably be my last trip for a long time. Little did I know what the future held for me—that I was actually going to be living my dream of helping Dogpatch out very, very soon.

I couldn't get Dogpatch out of my mind. When I wasn't adding photos to my page, I was thinking about it and wondering who was walking around up there. I could only hold out until May. I asked my friend, someone Michael and I had met on our first trip, who also knew the owner at that time if I could come up with him one Saturday. We did just that in May and I had the privilege of taking my friend

Waterfall bridge *[Eddy Sission]*

Sean on a tour, who had been there when he was a kid and wanted to relive his memories. At that point, I had seen the entire park, knew what the buildings all were and all the hidden surprises that the park held, such as the "staircase to nowhere" hidden in a grown-up area behind where the roller coaster once sat. Although I was comfortable just being there, I was constantly envisioning it cleaned up and cut. Little did I know I was only a few short months away from that dream.

In August, the rumor mill was really going. Word was that someone new had just bought Dogpatch and they were the inventors of a spill-proof plastic dog bowl. This initially spread fear into Newton county as the people envisioned the park demolished to make way for factories. The new owner didn't shy away from doing interviews. It quickly came out that he had a vision for the park: not to destroy it, but to rebuild it! Even if his intentions were true, I had to meet this guy and convince him what the park meant to me and others. Maybe he'd even let me be a part of this new rebirth. Maybe my dream could become a reality and I could have a hand in saving this precious place.

I went up early in September to meet the new owner after contacting them through Facebook. I was alone and did not have Michael as my usual moral support, but I couldn't wait on him. It had been since May that I was on the property and it was killing me. It was raining off and on that day. I was hoping that it wouldn't hinder a trip down to the park. I pulled up to the old ski lodge and the owner's assistant met and introduced me to everyone there.

Bumber boats [Michael Schwarz]

With a very distinctive echoing laugh, the owner came from another room. His light blue half buttoned shirt advertised his name on the right side of his chest. I expressed my interest in documenting the changes and publishing them on the Dogpatch page. We sat around the table and I was very uncomfortable. It was like I was being interrogated. The assistant was really friendly and so was the owner's extended family live-ins that were there. The actual owner at first seemed somewhat dismissive, but did take the time to talk to me, although he said he was very busy.

Once he found out I had the page, his demeanor was very positive. "I like what you're doing," he said to me. The whole time, I was watching the weather.

I said, "Do you think we could go down to the park?"

He replied, "Well, it's raining. Maybe today is not the day to do that."

My heart sank, and my face couldn't disguise my disappointment. He must've noticed the look I made and said that we could indeed walk around down there. I was silently ecstatic.

The park was so grown up. The spring that year really took its toll as the rainy weather had the weeds growing uncontrollably. He told me about the plans he had, one that involved a restaurant near the wooden car bridge that I was not supposed to repeat to anyone, repopulating the trout farm, and making it an eco-tourism destination. This was not going to be a plastics factory but an actual park again! If I was to describe his vision, it would be Dogpatch from the early 1990s, but more focused on nature and relaxing than rides and excitement.

Photo building *[Michael Schwarz]*

Swinging bridge *[Eddy Sisson]*

Cabin *[Eddy Sisson]*

I asked about volunteering before we headed back to the lodge and he replied that normally, he wouldn't want volunteers because they always had a sense of entitlement afterwards. I explained to him that I was unlike most people he ever met and all I wanted was to have the park going again. I also added that maybe my payment would be that he'd save the Wild Water Rampage. To my surprise, he accepted my offer. The dream was finally going to be realized! I was going to help with Dogpatch!

Later that same month, I took Michael out to meet the owner. It was weird having free access with one owner but having to prove ourselves to another. He came along with us down into the park for a while and I already missed the Dogpatch I had come to know. My Dogpatch. After a reminder from his assistant that he had to be in a meeting soon, they departed and left us to our own devices. We were free once again and it was all ours! Let me tell you that having the run of an abandoned theme park that everyone wants to get into is pretty exciting. It was more than that. This was my fifth multiple-day trip in a short time and Dogpatch was starting to feel like a home away from home. After an extremely fun trip hanging out and taking photos, we headed home, excited to see changes at Dogpatch we heard about and even making a few of our own. This would also change Abandoned Arkansas from a group that preserves history by taking photos to a group that takes action.

From September to November, not much was done. I'll admit I was surprised. I expected quick, big changes considering what was said to me personally and in interviews. The owner was planning an event in December—an invitation to

Cabin before (top) and after (bottom) *[Eddy Sisson]*

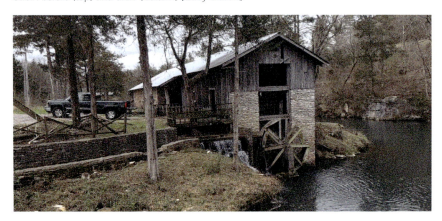

Gris Mill before (top) and after (bottom) *[Eddy Sisson]*

Eddy cleaning the administration building [Michael Schwarz]

come see the park legally for the first time since 1993. I went up in November and began my first cleanup session, which was helping his grandson clean up the administration offices. Specifically, the rainbow hollow restaurant side so that people could congregate and bands could play inside. It was happening—I was actually cleaning up Dogpatch and I was loving it.

Finally, in December, Michael and I went to document the event in which the owner called a "River Walk." Over 5,000 people attended that weekend to relive their memories. It was amazing. The owner was there getting handshakes and hugs from the locals. He promised them change and they ate it up. People were telling me their history with the park and I took their photos for the Dogpatch page. Although I have always been more of an anti-social person, it was interesting talking to the people, getting their stories and watching them tell their kids about the buildings and attractions like the trash eaters. It was a lot of fun and starting the next month, I would be going up to Dogpatch once or twice a month for the weekend. Sometimes that weekend would include early trips on Friday. From 2014 to 2017, I spent every vacation day from work I could at Dogpatch. I almost lived there.

Working month after month and seeing the progress on the structures was addictive. I would sometimes work past dark, occasionally getting up as early as 3:00 AM to go down and cut vines with my truck lights pointing at the buildings.

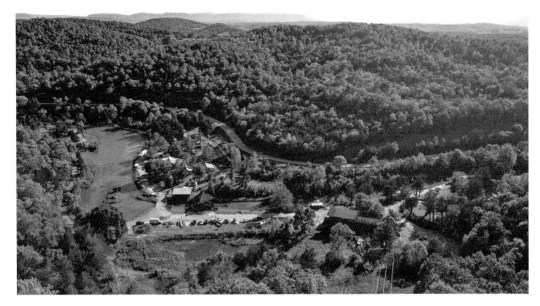

Aerial shot of Dogpatch *[Michael Schwarz]*

In January 2015, I truly began on the park like a madman. I had my opportunity and wasn't going to squander it. The first building I worked on was the Fish House, which was a former restaurant building. Vines had engulfed it and the weeds in the flower bed in front of it went up to my torso. The owner said that he was going to come down later, so I wanted to get as much done as I could to impress him. I wanted show him how serious I was. The day went on and I made a ton of progress. The shop, free of its prison of foliage, didn't look the same. The owner showed up late in the day. I thought that he would be down hours before this and was quite surprised, but he finally came, and his "WOW" was all I needed.

The next month, Michael came with me and we started on Kornvention Hall, cleaning the famous stage and town square. The dirt had eroded and collected by the stage and weeds and small trees were growing in front of it. Again, we were left to our own devices. We had proven ourselves to the owner and had gained his trust. Even though it was February and it was cold, we had so much fun clipping vines, shoveling dirt, and just talking. We were really bonding out there, just the two of us. I guess I dragged him into my dream, but he was more than willing.

When we weren't working, we also did a lot of security. I spent countless hours that you could add up into days just driving around the entire park, usually after working and until the early morning hours, when I would get a nap in and redo the process the next day. I figured the more I was down there, the more I could keep

Bridge and Gris Mill *[Michael Schwarz]*

Downtown Dogpatch *[Michael Schwarz]*

Abandoned Dogpatch [Michael Schwarz]

an eye of everything and keep it safe. There would be plenty of times I'd come back and something would be kicked in or a new hole would be punched in a wall. The only way I knew to prevent that was to be a constant presence.

At my job, to this day, I still get off work at 2 AM. For the March 2015 trip, I asked Michael if he'd be willing to go up there after I got off work one weekend for a nighttime clean-up session. He was down. I had a hard time convincing the owner about working at night. Over the past several months, we have all become friends, especially his assistant, who was closer to our ages. We pleaded with her and she convinced him that it wouldn't be a big deal. I understood his concerns, but I just wanted to get as much accomplished as I could. We left our homes at 2:00 AM, and as the sun broke, we had all but finished cleaning out the inside of the Riverbend Music Show building in town square. It was great.

We worked on the outside and inside of a few other structures in town square that weekend, including the old funnel cake shop and glass blower's shop. One of the shops had all of its windows busted out and the glass was on the porch, which we cleaned up. It was around this time that I began to notice that it was March, and we were the only ones doing anything in the park.

Admittedly, it was cold, but I had figured that would be a good time to dig in while the summer sun was on a vacation and the vegetation lay mostly dormant.

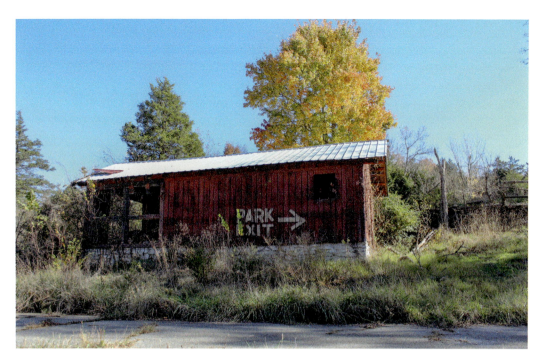

Park exit [Michael Schwarz]

There was no sign of activity from the owner. I didn't ask any questions, as I was just happy to be living the dream. I also noticed our dirt piles from the month before were still there, starting to slightly spread out from the falling rain. Piles of sticks were still where I had left them, even though it was promised they would be picked up after we had left. Weird.

April brought warmer weather and news of a second River Walk event in the following month. I brought up my friend Blake that weekend and it was a blast. I worked, and Blake fished. At night, we would get intoxicated and do security watching for eventual trespassers. Knowing that the second event was next month, I got as much done as I could, and I completely took the old sign shop back from nature that sits in front of the train station.

The second River Walk the following May of 2015 was different. The dynamics of the owner and his live-ins had drastically shifted at this point and now only the assistant, who seemed angry and frustrated, remained. The owner was not there for the event early on, but came down later in the day. I could tell something had changed. Demeanors were negative and plans were somehow falling apart. Whatever motivated, positive, ambitious talk that began in September of last year was now eight months later a mostly reclusive silence or fireballs of negativity. I wish I could say that situation would change, but it didn't—it only got worse.

Marble Falls *[Eddy Sisson]*

Trout Farm *[Michael Schwarz]*

I could go into detail of month after month, trip after trip, telling tales of me ripping vines from buildings, sweeping out buildings after air soft events, mowing the train tracks, slowly clearing the cabins from ivy and weeds, and events being held in the park, but they would all be very similar. No construction crews ever came, no repairs were made, and aside from another group out of Harrison, only myself and the people that I gathered came and worked.

Posting the photos on social media created awareness of what I was doing, and I was able to gather a few others in the fight alongside me and Michael. There were a lot of people who would show up maybe once or twice, but there was also a group of regulars. Those regulars would eventually become like a family to me. The friendships and memories we made were my reward at the end of my journey. Nights of hanging out on the Kornvention Hall stage taking shots and getting drunk after a grueling work day of slinging weeds, driving around the park listening to music, the night we stayed up until 3 AM painting the Honey House, doing impersonations with Wendy, sitting in my hammock near the waterslide, riding around with Cree on the four-wheeler, scaring trespassers, the night Poe and I played cat and mouse with our cars—I truly had the time of my life. I love my Dogpatch tribe and they know who they are.

That's not to say that there weren't bad times, though. There were terrible times and I put up with a lot of needless drama at the end of the day. But the details of

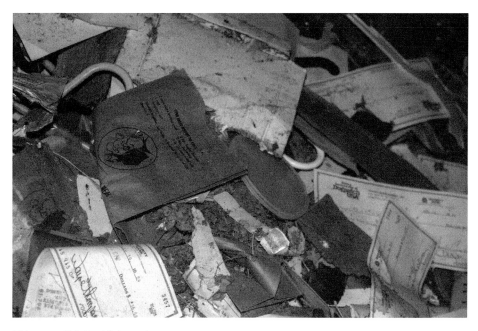

Old papers *[Michael Schwarz]*

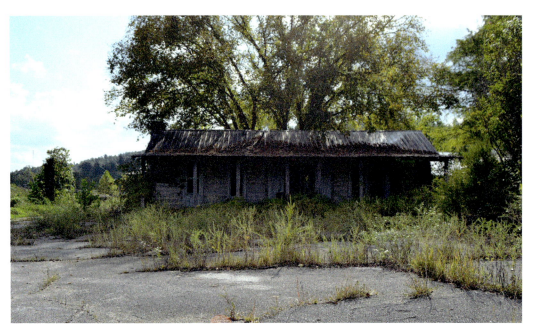

Photo: *Eddy Sisson*

those stories will have to wait for another time. Until then, I'll just say for Dogpatch it was worth it.

I had just started on a new project near the end of 2017, which was reclaiming the Old 99 kid's train station and railway, when the owner told me that someone was coming to look and possibly buy the park. My mind kept telling me he was crazy. Who would buy the park in its condition? Were they insane? I mean, I would buy it, but then again Dogpatch had my heart.

Details were sparse, but eventually by Thanksgiving Day 2017, the deal was made and overnight I was on the outside looking in. Once I found who the party was that had leased the park, my heart sank, and I feared for the fate of the park. I still wanted to do help Dogpatch any way I could, no matter who owned the property, but it was not to be. After all I had done and all I wanted to do, my dream was dead and my story over.

The final, sad outcome of my Dogpatch adventures ended very badly. Though the new company was coming in, I was never introduced to them and when I tried to introduce myself, I was met with hostility. We had lost our home that we help make beautiful again after three solid years of sacrifice. Even with the knowledge of what my team and I did, as well as knowing the reach of my Dogpatch USA Facebook page, they wanted nothing to do with me. In the end, narcissism, lies, and drama would eventually make us leave and never look back, which, again, is a story for another time.

As a team, we've had other projects since, including helping out at the Mountainaire Hotel and the Mountain Village 1890. Preserving history is what we are all about and that's exactly what we'll do. I miss Dogpatch and not a day goes by that I don't think about her and again wonder who's walking around up there, just like I once did so long ago. But a wise person once told me that Dogpatch was not an ending, but a springboard, and I took that advice to heart so I can accomplish my new dream—saving as much Arkansas history as I can.

*Right:* Old sign *[Michael Schwarz]*

*Below:* Dogpatch cabin *[Eddy Sisson]*

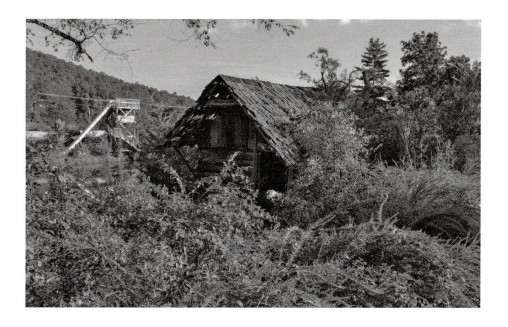

# 3

# A NEW ADVENTURE IS ALWAYS WAITING
By Ginger Beck

My first true urban exploration as part of Abandoned Arkansas took me less than twenty miles from home, a facility with a multi-faceted history, now left exposed to the elements, stripped of copper and valuables. The Alexander Human Development Center stands massive around a sharp corner of road in Alexander, Arkansas; a 90-degree angle shaped, three-story building with multiple outbuildings on the grounds.

The history of the building dates back as far as the 1930s. Prior to the 30s, tuberculosis ravaged the country, and in 1881, Arkansas legislature realized the necessity of creating a state board to monitor the disease, sanitary conditions, and collect statistics of importance. The first sanatorium was founded by Pulaski County Senator Kie Oldham, who suffered from the disease himself. Because of segregation, it became a necessary step to establish a sanatorium for African Americans, the McRae Sanatorium. By 1940, its operations began providing nurses' training; in 1960, a children's building and auxiliary nurses building was added. The patient population at that time had grown to 390. At its pinnacle, the sanatorium had room for 411 beds.

After thirty-seven years of racial segregation, the McRae Sanatorium was finally allowed to merge with the Booneville State Sanatorium in 1967. The Booneville facility, which was much larger, closed five years later in 1972, as treatment for tuberculosis made such facilities obsolete. The former McRae Memorial Tuberculosis Sanatorium for Negroes was converted into the Alexander Human Development Center, where its history continues. Arkansas had fallen behind other states in regard to facilities that were designed for long-term care of individuals with severe mental illness and/or intellectual disabilities, but in 1968, the AHDC became a part

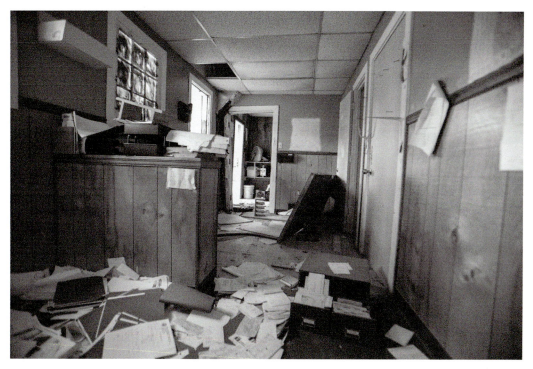
Admin building (Alexander Human Development Center) *[Michael Schwarz]*

Peeling Paint (Alexander Human Development Center) *[Michael Schwarz]*

Cafeteria (Alexander Human Development Center) [Michael Schwarz]

of the Arkansas Department of Human Services for individuals with developmental disabilities. It offered occupational, physical, and speech therapies and provided psychological assessment, medical care, rehabilitative services, community development, and outreach services.

After years of operation, following a series of failed safety inspections, the loss of Medicaid certification, and patient rape allegations and investigations on the part of the staff, the Alexander Human Development Center was closed in 2011. This closure was a difficult one in the community and region surrounding the facility, especially with families who depended on the facility to help care for loved ones in need of services. Despite petitions and complaints, it remained closed, ending eighty years of public service. Remaining patients were displaced to a range of alternative care placements, including four other remaining human treatment centers.

When I visited, the center was a shell of what once housed hundreds of patients and employees. The day was hot, but with the broken windows and a nice wind, walking its halls was surprisingly cool. Graffiti kept me company, and any hesitancies of touring the place alone fell away as I laughed and was simultaneously impressed with some of the artwork or poetry-like words sprayed on walls. Only one room still had a bed and dresser bolted to the floor and walls; all other remains of furniture and such had been removed. Scattered puzzle pieces and coloring pages in the recreation rooms, formerly sunlight rooms for tuberculosis patients, lay scattered about. I spent several hours there on my first visit, taking in the quiet and the history.

Thankfully, there could be a happy ending for this massive structure; on a return visit, our group talked to the Alexander chief of police, who said they would be using one of the intact buildings as a substation and using the large building itself for SWAT training. Perhaps a building once meant to heal and help will continue in some fashion to help prepare and train officers, in a way still providing help and service to the community and state.

Kitchen (Alexander Human Development Center) *[Michael Schwarz]*

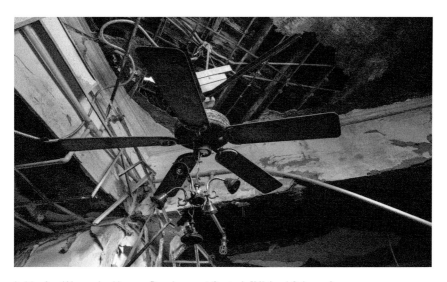

Lobby fan (Alexander Human Development Center) *[Michael Schwarz]*

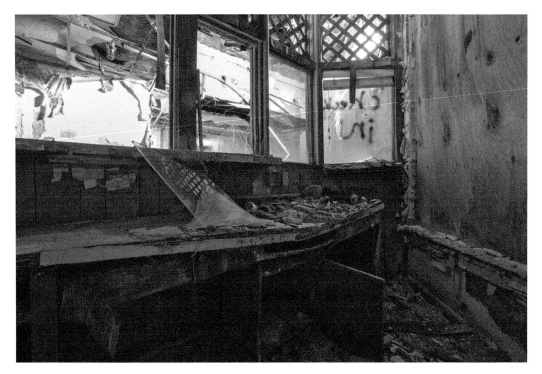

Lobby desk (Alexander Human Development Center) *[Michael Schwarz]*

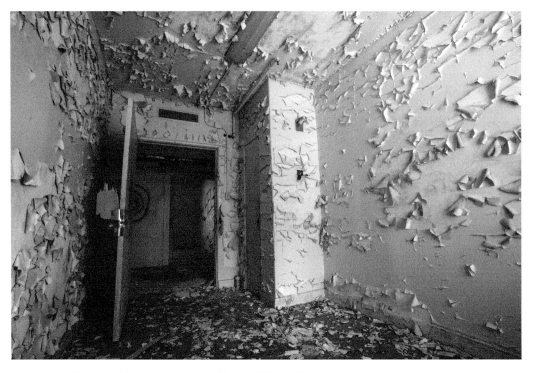

Patient room (Alexander Human Development Center) *[Michael Schwarz]*

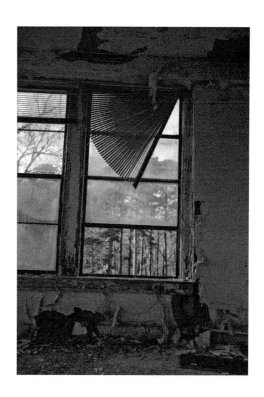

Window (Alexander Human Development Center) *[Michael Schwarz]*

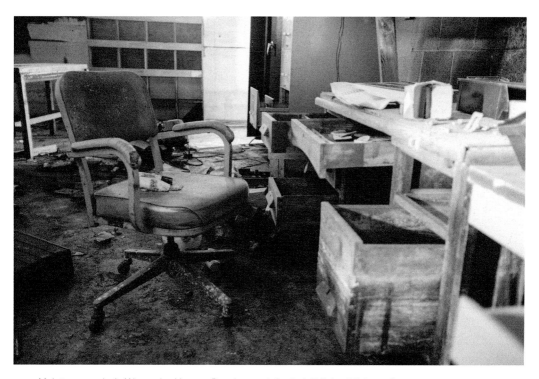

Maintenance desk (Alexander Human Development Center) *[Michael Schwarz]*

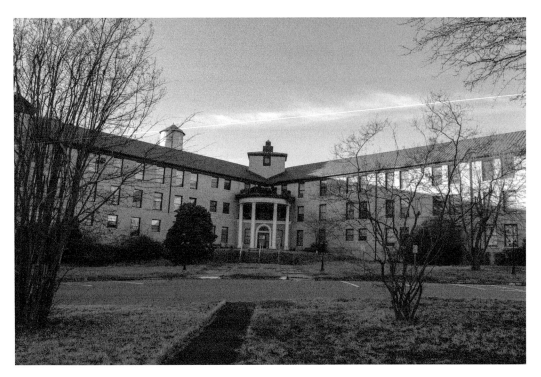

Alexander Human Development Center *[Michael Schwarz]*

## Carden Bottoms

Down a dusty road, not far from Petit Jean Mountain, are the stones outlining what remains of the Carden Bottoms school house, once the center of a thriving little community named for the James Carden family who settled there in the early 1800s. A few farms and homes are left, but the local church is abandoned and overgrown. Built in the 1920s, the school was constructed with carefully fitted and mortared local stones. Almost 100 years later, the building was still standing, albeit dilapidated and overgrown by foliage that hid it from easy view, a hot spot for photographers and explorers. Abandoned in 1970, the school, sadly, in October 2017, was destroyed by arson, leaving only the stone gymnasium and stone foundation.

When I visited, the fire had destroyed the six classrooms just a few months before. Police tape still remained in places, and the school was easy to see in winter through the naked trees. The shape of the hall and classrooms, the walls and windows, were and are still intact and strong, leaving behind the blueprint of what the school was like in its days of operation. It housed six large classrooms, three on each side of a central hallway, with high ceilings and outer walls covered by extensive banks of windows, the standard at the time to allow for cooler rooms and as much light as possible.

Carden Bottoms School, Carden Bottoms, AR
*[Michael Schwarz]*

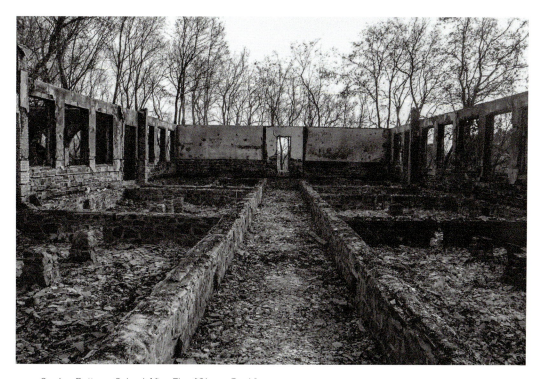

Carden Bottoms School After Fire *[Ginger Beck]*

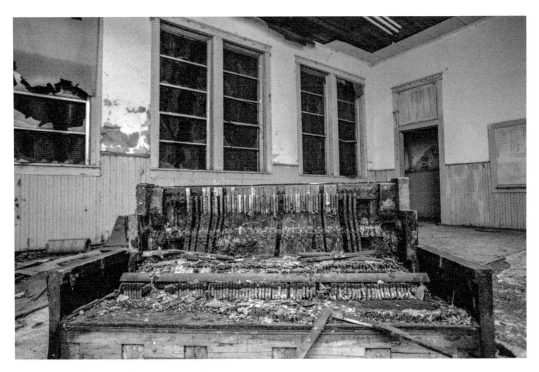

Carden Bottoms School *[Michael Schwarz]*

When first explored by Abandoned Arkansas, there were even two pianos that remained. Post fire, the tangled remains of wire from each piano sit in the rubble.

Thankfully, what remains of the separate gymnasium building that was constructed right beside the school still remains, connected by a strong and elaborate arch stone fitted walkway. The interior of the gymnasium building has completely collapsed. A stone set high above the outer doors on the front walls bear the words "Carden Bottoms Gymnasium" and the year "1936."

Sadly, the heart of the town that has disappeared has stopped beating, but the beauty of even what remains post-fire is undeniable. Craftsmanship and stone cannot be defeated by fire, nor can memories.

Carden Bottoms School *[Michael Schwarz]*

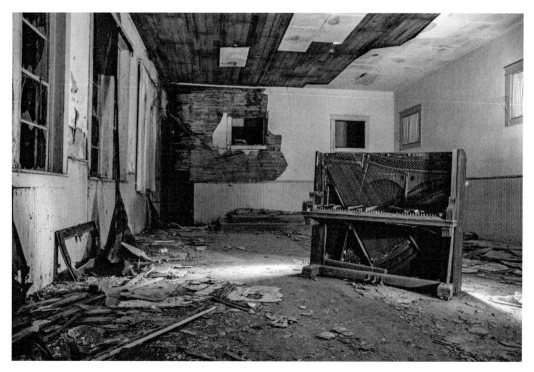

Carden Bottoms School *[Michael Schwarz]*

Carden Bottoms School *[Michael Schwarz]*

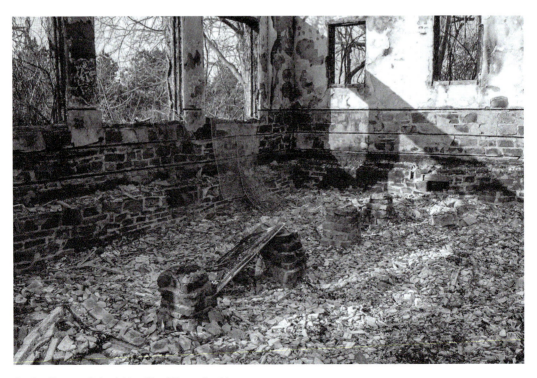

Carden Bottoms School After Fire *[Ginger Beck]*

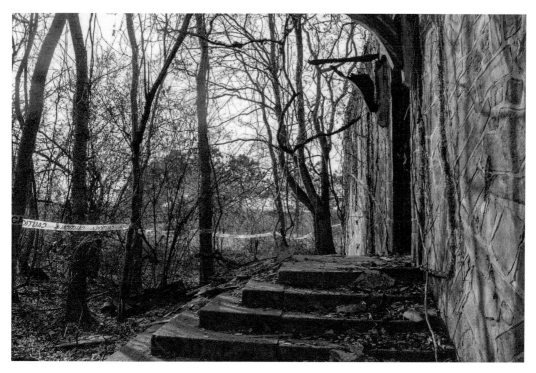
Carden Bottoms School After Fire *[Ginger Beck]*

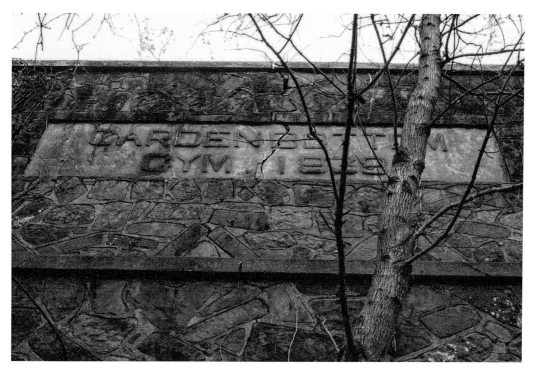
Carden Bottoms School After Fire *[Ginger Beck]*

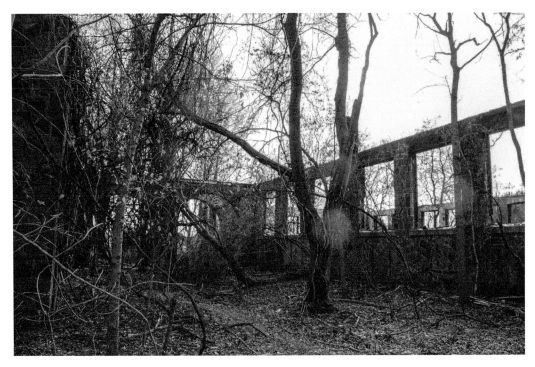

Carden Bottoms School After Fire *[Ginger Beck]*

## THE SAENGER THEATER

It's hard to imagine a place with so much history and life being empty, but that is the case with the grand and opulent Saenger Theater in Pine Bluff.

When I visited, it was hot and dusty, but the vibrancy of life was palpable. Empty popcorn bags hinted at what could have been someone's snack just a day ago—but it has been much longer than that.

It opened on November 17, 1924; called "the Showplace of the South," it made Pine Bluff a hub of entertainment for people in all surrounding areas. The Saenger brothers built around 300 theaters in the South during the 1920s; sadly, fewer than 100 remain.

Costing almost $200,000 to build, the Saenger Theatre was a stunning showplace, holding 1,500 seats on both the lower floor and the balcony. As standard for the time, the white theater goers sat in front of the balcony, leaving African American to enter by the side door, leading to the top of the balcony. Marble floors, a crystal and prism chandelier, and a full-sized Broadway stage provided the perfect setting for big acts to perform: Al G. Fields Minstrels, Ziegfeld Follies, and other traveling theatrical groups.

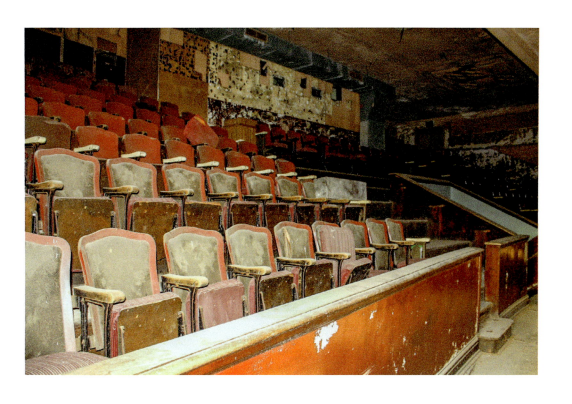

Saenger Theater *[Ginger Beck]*

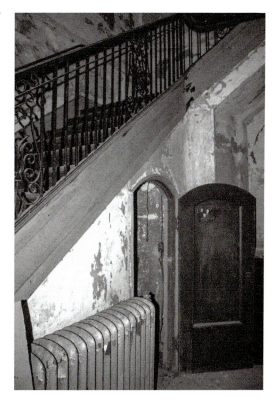

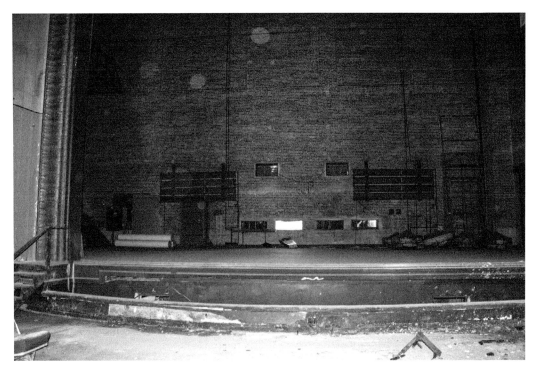

Saenger Theater *[Ginger Beck]*

Arkansas citizens in the area prepared for weeks for the grand opening. Saenger Theatre's week-long event set a new attendance record for the matinee and evening performances. Dinner parties were held at the nearby now historic Pines Hotel. On the front row of the Saenger sat movie stars: Gloria Swanson, Norma Talmadge, and producer D. W. Griffith, along with proprietor Julian Saenger.

Magician Harry Houdini performed his great act on the stage and hired a local youth, Stanley Clark, to be his stooge. Clark later also performed magic acts for children on the same stage.

There were children's shows on Saturdays, with the price of admission being an empty Coke bottle. It once drew the likes of Gloria Swanson, Norma Talmadge, D. W. Griffith, and Judy Garland.

Audiences regularly filled the theater's 1,600 seats to see performances by Harry Houdini, Will Rogers, and John Phillips Sousa, as well as Roy Rogers and his horse, Trigger.

Even local events such as school plays, high school graduations, and dance recitals were held there. A new marquee was installed during the 1950s, and the letters still remain.

The Saenger sadly closed its doors for around 1975; new theaters were being built in shopping centers. People were beginning to stay away from downtown Pine Bluff.

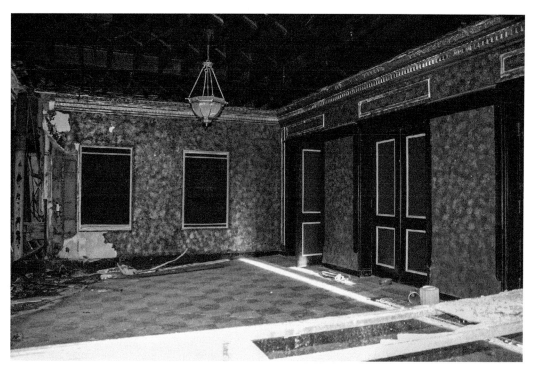

Saenger Theater, Pine Bluff, AR *[Ginger Beck]*

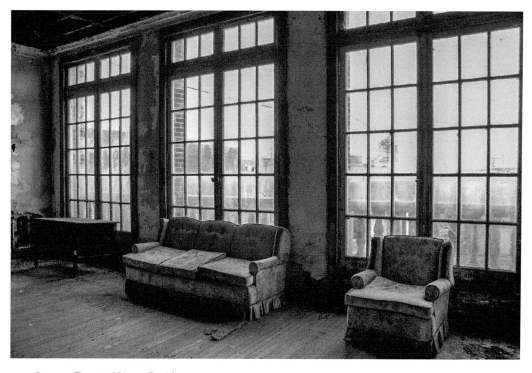

Saenger Theater *[Ginger Beck]*

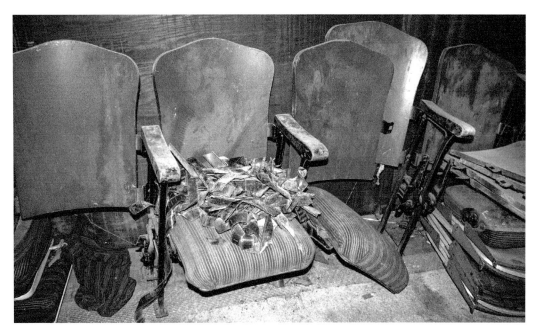

Saenger Theater *[Ginger Beck]*

The Saenger was given to a non-profit group, the Heckatoo Heratige, whose mission it was to save old buildings and homes. On May 13, 1996, it was transferred to another non-profit group, Friends of the Saenger, now known as Old Towne Centre Theatres, Inc. Their mission is to celebrate the art of silent films and to restore the theater to its original condition.

A new roof was installed, the bathrooms were painted, and local prisoners were commissioned to clean out the projection booth, orchestra pit, and basement. Five hundred seats were added downstairs. The orchestra pit was covered, and sump pumps were installed in the basement for flooding. Gold curtains donated by the Miss America Pageant were hung in front of the newly installed movie screen. The concession stand was remodeled, and another bathroom was installed behind it. The old marquee was taken down, the front was painted, and murals were added.

The Saenger Theatre was listed on the National Register of Historic Places on March 23, 1995. Local community leaders worked to fund the restoration of the theater with hopes of revitalizing the downtown area, and, in January 2012, the City of Pine Bluff accepted ownership of the theater, which was donated by the nonprofit Old Town Theaters Centre Inc.

The legacy of the theater remains. The streets of Downtown Pine Bluff are ghostly. It is rare a car drives by. People want to save the Saenger, but is it possible to revive it again in a dying economic area? The future is uncertain.

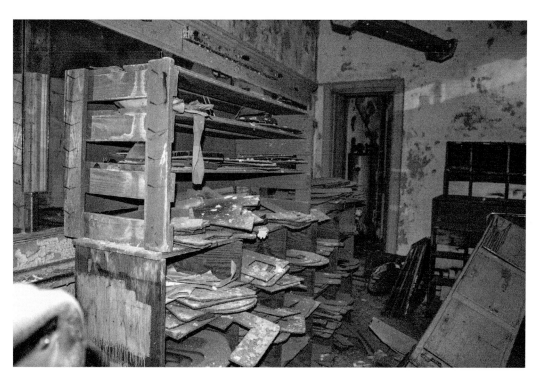

Saenger Theater *[Ginger Beck]*

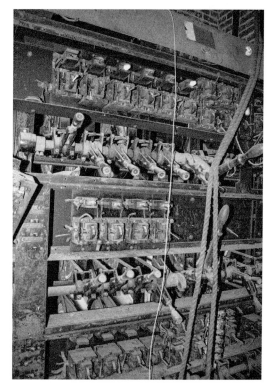

Saenger Theater *[Ginger Beck]*

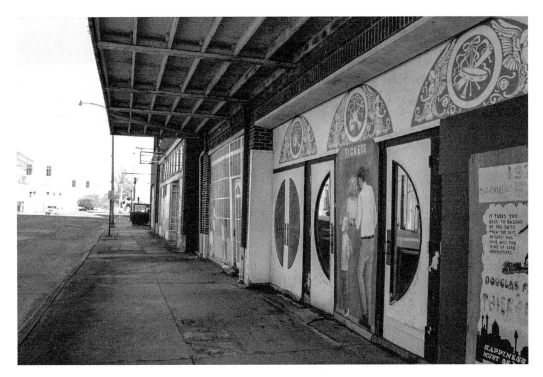

Saenger Theater *[Ginger Beck]*

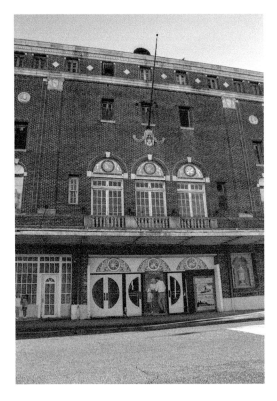

Saenger Theater *[Ginger Beck]*

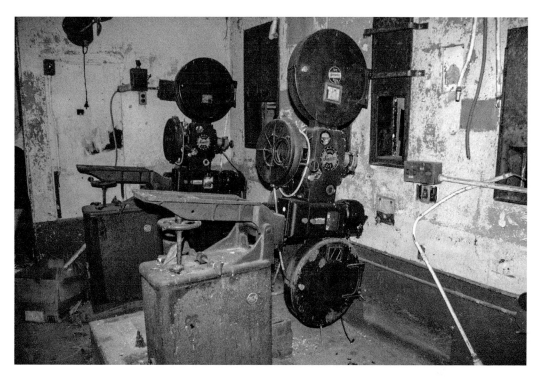

Saenger Theater, Pine Bluff, AR *[Ginger Beck]*

## THE HISTORIC WILLIAM E. WOODRUFF HOUSE

The Historic William E. Woodruff House is an amazing and important structure, as it was the home of founder and longtime editor of the Arkansas Gazette; it is one of the few antebellum homes remaining in the capital city and was added to the National Register of Historic Places on March 21, 1989.

Woodruff established a successful business as an agent for non-resident owners of military lands in Arkansas Territory, and the additional revenue enabled him to construct a two-story, brick building at the northeast corner of Markham and Scott streets. In March 1827 he moved the Gazette, as well as his book business and land agency, into the building.

While a single man, Woodruff and his apprentices lived in the various newspaper offices. On November 14, 1827, he married Jane Eliza Mills. The Woodruff family lived in the building at Markham and Scott streets until the early 1850s. By 1850 downtown Little Rock had grown considerably and so had the Woodruff family. William and Jane Eliza Woodruff had eleven children, eight of whom survived to adulthood

Woodruff sought an area in the country where he could have a small farm and his children could play, so he bought about 25 acres east of downtown Little Rock. His

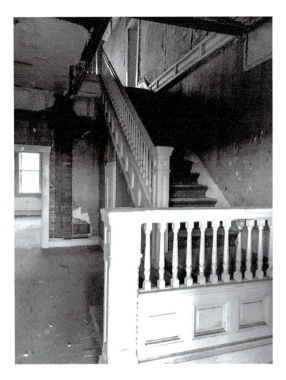

Woodruff House, Little Rock, AR *[Ginger Beck]*

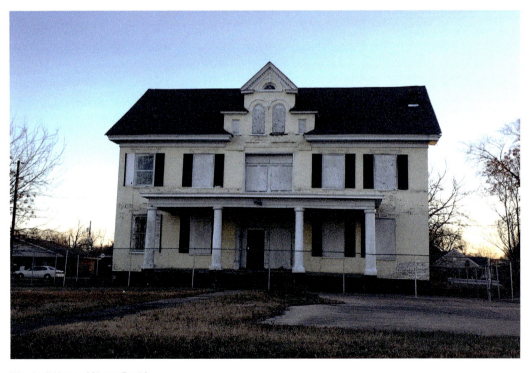

Woodruff House *[Ginger Beck]*

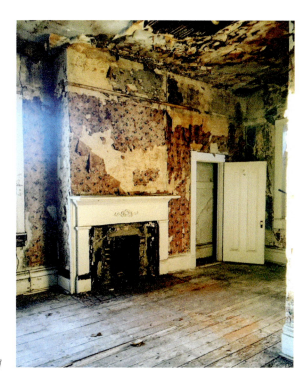

Woodruff House *[Ginger Beck]*

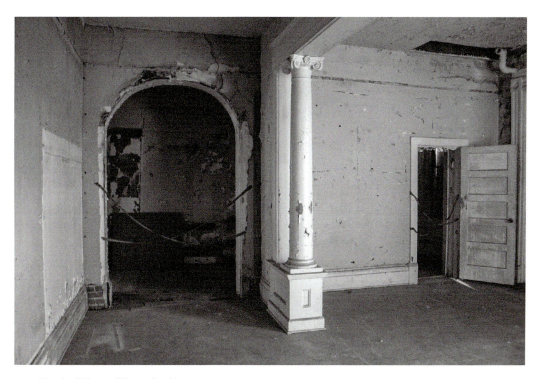

Woodruff House *[Ginger Beck]*

land was roughly bounded by Rector, College, Seventh, and Ninth streets. In the spring of 1852, Woodruff hired local builder John Robins and his son, Louper, to construct a large, 2 ½-story house facing south on East Ninth Street. The house was built with locally-made bricks and likely had a one-story Greek Revival-style front porch.

The Woodruff family moved into the new home in March 1853, and a few months later an "ell" was added onto the northwest corner of the house for a pantry, dining room, and kitchen. The house was set far back from Ninth Street and had a circular carriage drive.

The Woodruff House was truly an urban farmstead, complete with an orchard, gardens, stables, servants' houses, and open pasture. The orchard was on the west side of the front yard and supplied a plentiful amount of fruit. A 2-acre vegetable, fruit, and flower garden was on the east side of the house with a grape arbor and bee hives in the center. The horse lot was just north of the garden, along with the barn and stables, pig pens, and tool shed. A carriage house, poultry yard, and other outbuildings were located in the back yard as well (north side of the house; now the front yard). The servants' houses were located on the north side of the house and faced south, each equipped with a large fireplace.

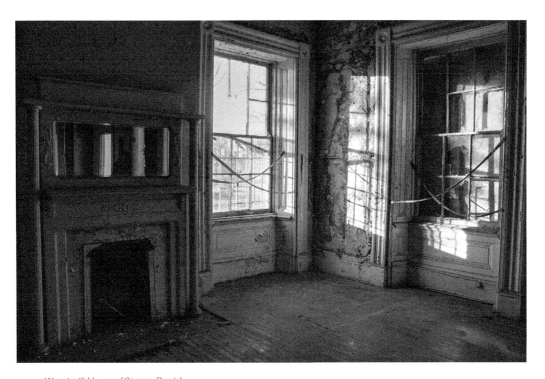

Woodruff House *[Ginger Beck]*

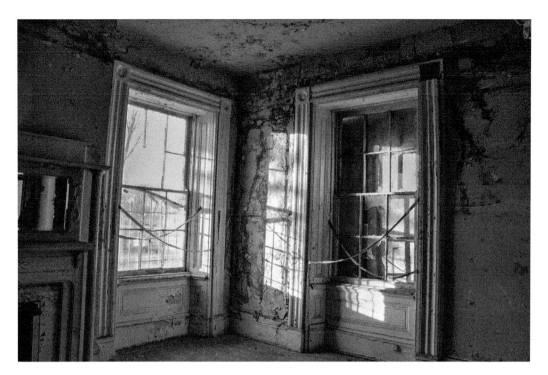

Woodruff House *[Ginger Beck]*

After Little Rock fell to Union forces on September 10, 1863, Federal troops took possession of the land surrounding Woodruff's house. During the Federal occupation Woodruff, an ardent supporter of the Confederacy, wrote a letter to a friend that was intercepted by the Union army. On March 10, 1864, General Frederick Steele banished Woodruff from Little Rock and took charge of his home. But Jane Eliza Woodruff and her daughters were allowed to occupy two rooms in the house for a few months before seeking shelter with friends. While in possession of the Union army, the Woodruff House served as officers' headquarters as well as a military hospital (possibly part of the U.S. military hospital established at nearby St. John's College). Woodruff returned to his home in September 1865.

Woodruff lived in the house with his wife, Jane Eliza, until his death on June 19, 1885. Woodruff's eldest child, Alden Mills Woodruff, occupied the house from 1886 to 1891, when the home was sold out of the family.

About 1900 the orientation of the Woodruff House was reversed to face north on Eighth Street. The original porch on the south side of the house was removed and the original front door opening filled in with a ribbon of three 2-over-2, wood-frame windows. By 1906 a semi-circular porch set on a rectangular base was constructed on the north side of the house. Both levels featured a decorative balustrade. A set

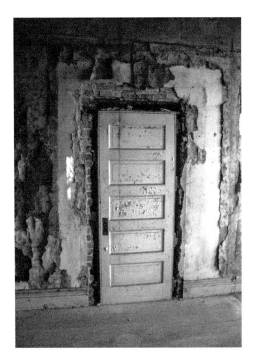
Woodruff House *[Ginger Beck]*

of double doors with transoms was situated in the center of the first and second story, providing access to both levels of the front porch. To complete the home's reversal, a gabled dormer with rounded arch windows and a fanlight was added to the center of the north façade.

In 1921 the Woodruff House became the Cottage Home for Girls, which provided room and board to out-of-town women working in Little Rock. The Cottage Home had 12 bedrooms, each set up to house two or three girls, and provided residents with two hot meals a day. The price ranged from $4 to $5.50 per week. By 1924 the semi-circular front porch was replaced by a rectangular porch with a balustrade on the lower level. Perhaps the rectangular porch was added about 1920 when improvements were made for the incoming Cottage Home for Girls.

By 1930 the Woodruff House was the Colonial Club for Business Girls, and it remained a boarding house or apartments until 2005, when the house sustained fire damage.

Although no major structural elements failed, the Woodruff House has been vacant since the fire and has deteriorated considerably. Many of the home's first floor windows are broken or boarded, leaving the Woodruff House susceptible to further damage from vandals and the elements. The Woodruff House is currently for sale by the Quapaw Quarter Association, who graciously let me tour this gorgeous piece of Arkansas and American history.

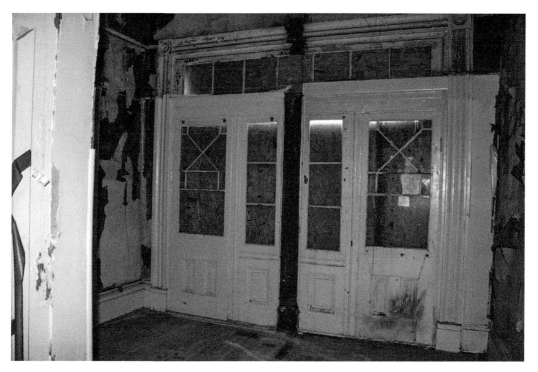

Woodruff House *[Ginger Beck]*

Woodruff House *[Ginger Beck]*

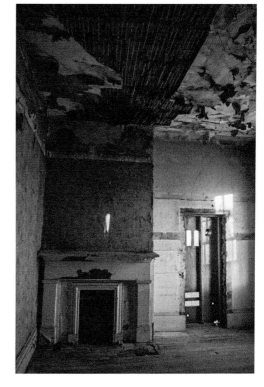

# 4

# THE NEGOTIATOR
By James Kirkendall

I am always asking myself, "What's behind that door?" My name is James Kirkendall and I am one of the active photographers for the group "Abandoned Arkansas." I have been told that I am sort of a "renaissance man." I have always tried new adventurous things in my life, whether it's in the norm or completely unique. The experiences I have had with "Abandoned Arkansas" have been extremely unique.

I started out on the "Abandoned Arkansas" team as a guest photographer at first and had very little experience or knowledge of working a camera. The more places I document the more I can see my camera skills improve. I eventually earned the title as the team negotiator because of my public relation skills with property owners. Schools, jails, amusement parks, factories, government facilities, and hotels just sparked my interest. Of course, we cannot forget about old hospitals, which are most likely my favorite type of exploration. The team assigned me the task of obtaining permission to shoot at a hospital that was the definition of why we explore and document.

Persistence. It's the key to any negotiation. My plan usually starts out by finding the best way to approach a property owner. Liability injuries can be a huge issue these days. Of course, it's easy to understand why an owner can be hesitant to let anyone on their property. Sometimes a building can be easy to get into and others not as much. Broken floorboards, missing staircases, and airborne toxins are just a few hazards we face. I always have to reach out to someone like an individual, the city, county, state, or chamber of commerce to get permission. In some cases, I have waited months before I get the final answer. Thankfully, for the most part, the answer is a "yes" in the end.

Warner Brown Hospital, Booneville Community Hospital, Verser Clinic Hospital, Fayetteville City Hospital, Eastern Ozarks Medical Regional Health System, Arkansas Tuberculosis Sanitorium, and Fort Chaffee Hospital are all the Arkansas hospitals

Eastern Ozarks Regional Health System, Cherokee Village, AR *[James Kirkendall]*

Eastern Ozarks Regional Health System
*[James Kirkendall]*

Eastern Ozarks Regional Health System *[James Kirkendall]*

I have had the opportunity to explore or partially explore. Some were built in the early 1900s and some in the 1970s.

Eastern Ozarks Regional Health System is probably one the youngest locations on the list that I have explored. I usually hear the remark, "I don't understand why you would want in there." All buildings have history. If the location has a significant purpose, it's worth documenting no matter the age of the building. This location is the definition of what's left behind. Half of the hospital is in disrepair and the other half looks as if it was never used.

> Practicing medicine isn't just a science, it's an art. The art of taking care of human beings. Sometimes it's got to be about the patients and not the money.
> Dr. Jackson, Eastern Ozarks Regional Health System

Unfortunately, the hospital's funds weren't sufficient enough to bring it up to current codes and federal regulations. It was renamed twice in its years of operation and had several ownership changes. Originally called Eastern Ozarks, its name changed

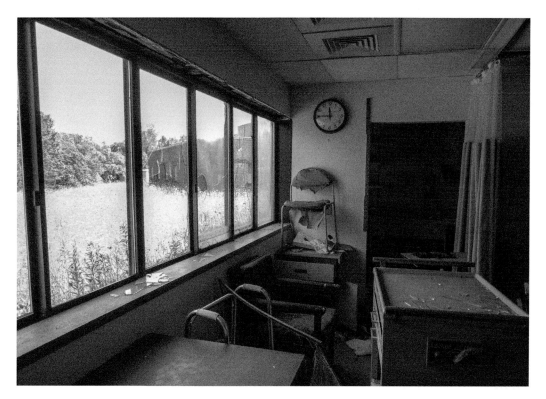

Eastern Ozarks Regional Health System *[James Kirkendall]*

to Baptist Memorial Hospital. The hospital's revenue increased to three million, allowing expansions. Its name was once again reverted back to Eastern Ozarks Regional Health System. In 2004, the hospital was forced to shut down due to its inability to operate a twenty-four-hour emergency room. The hospital was gifted to the City of Cherokee Village but was returned to the State of Arkansas after the city council voted not to pay the remaining lien.

The hospital was filled with computers, files, books, television sets, beds, radiology equipment, gloves, syringes, x-ray machines, refrigerators, desks, examination lights, and wheelchairs. Everything you could imagine in a hospital appeared frozen in the test of time. One of my biggest memories of touring Eastern Ozarks was the laboratory. I usually do not get chills while exploring but this room had such a surreal feeling to it. I believe this was a situation where photography wasn't up to par. The best way to describe the room would be to wear a virtual reality headset or play a futuristic-horror video game. I could hear the water dripping from the ceiling, giving it an eerie atmosphere. It was like a scene from a movie.

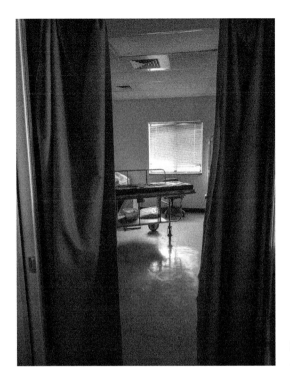

Eastern Ozarks Regional Health System *[James Kirkendall]*

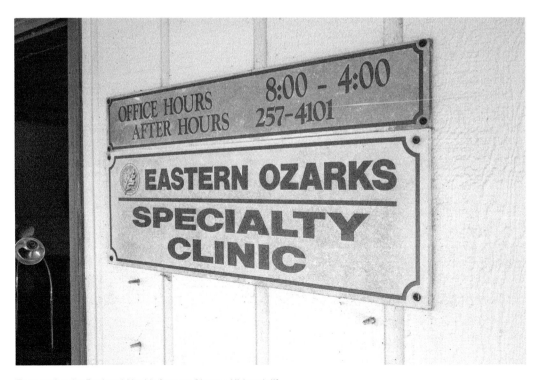

Eastern Ozarks Regional Health System *[James Kirkendall]*

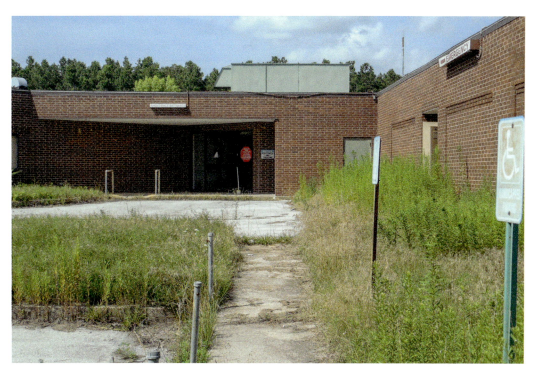

Eastern Ozarks Regional Health System *[James Kirkendall]*

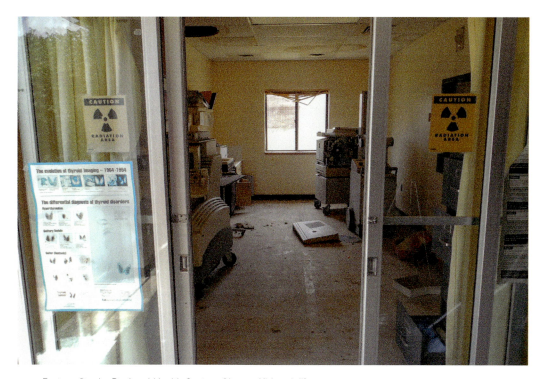

Eastern Ozarks Regional Health System *[James Kirkendall]*

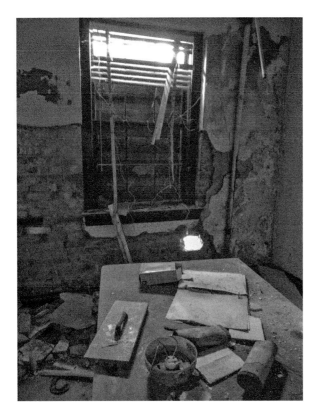

Verser Clinic Hospital
[James Kirkendall]

It wasn't that I was that good, I was just cheap, affordable, and available.

Dr. Joe Verser

My list of documentations wouldn't be complete without Verser Clinic Hospital. By the time I went on this exploration, I had a good idea of which historic buildings were in Arkansas. I even knew of places outside of the state. I would search deeply online, and use google maps and street view to scout out locations. I had never heard of this place. I was heading to another location and drove through Harrisburg. It seemed as if I could sense this building miles off. My wife Ashleigh accompanied me on this trip and I told her, "I bet anything this is a hospital." We walked up to the front and sure enough, "Verser Clinic Hospital" was engraved on the front of the building.

In the town of Harrisburg, the friendly people directed me to the owner's house. I met Sylvia Evans and her son Daniel, along with their friend Brandon. I explained to them I had to tour the former hospital. Being the executive director of Poinsett County, Sylvia had an entire room full of historical and genealogical records. Some literature she even wrote herself. She explained to me how the clinic was built from a church building in 1949. Dr. Joe Verser must have been an exceptionally dedicated physician

Verser Clinic Hospital *[James Kirkendall]*

as he and his wife lived in the back rooms of the hospital. I could even see evidence that the rooms in the back might have been an apartment. He was an influence to the medical field even outside of Harrisburg, as he was one of the founders of Arkansas BlueCross BlueShield health insurance and delivered over 5,000 babies.

Even though the clinic was owned by a small-town family doctor, the facility was equipped with some of the most state-of-the-art equipment. It featured an air-conditioned surgery room, nursery, delivery room, kitchen, laundry room, x-ray facility, elevator, and an intercommunications system so that the nurses could speak to one or another as well as the patients. As of right now, it's an empty shell of a building. Some things have been placed in the Marked Tree Delta Area Museum. There are very few remnants left in the buildings, such as sinks, latrines, chairs, bathtubs, and air/heating units. However, that doesn't mean the location shouldn't be any less significant. The old building is chock-full of history. Sylvia Evans knows this and wishes for the building to become the Poinsett County's new historic museum someday. The building has been nominated to be on the National Register of Historic Places. Hopefully, with the right amount of interest, perhaps the location will be a state-level landmark, as it should be.

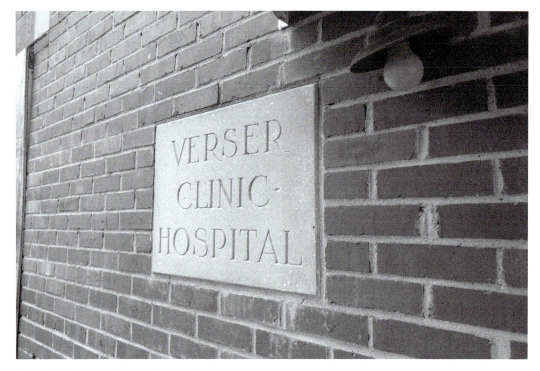

Verser Clinic Hospital *[James Kirkendall]*

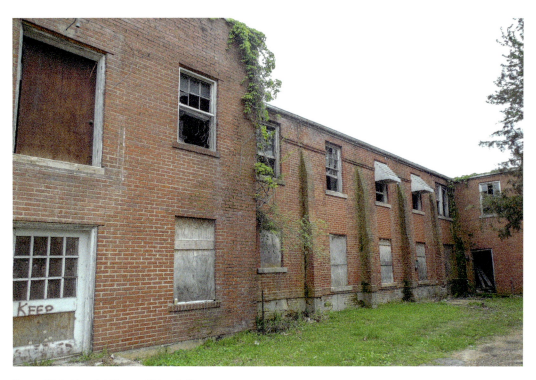

Verser Clinic Hospital *[James Kirkendall]*

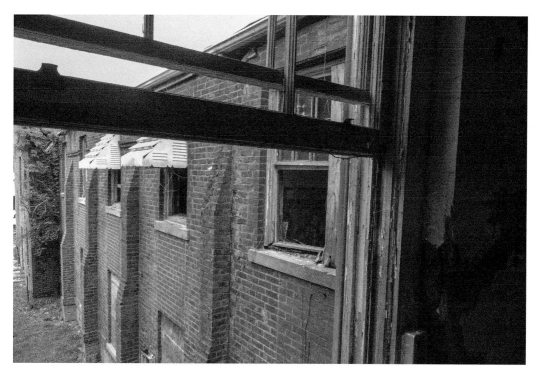

Verser Clinic Hospital *[James Kirkendall]*

Verser Clinic Hospital *[James Kirkendall]*

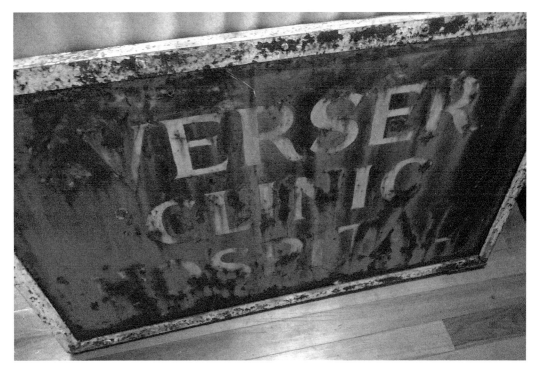
Verser Clinic Hospital *[James Kirkendall]*

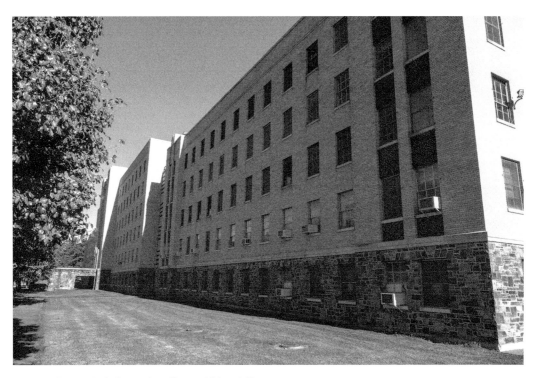
Arkansas Tuberculosis Sanatorium *[James Kirkendall]*

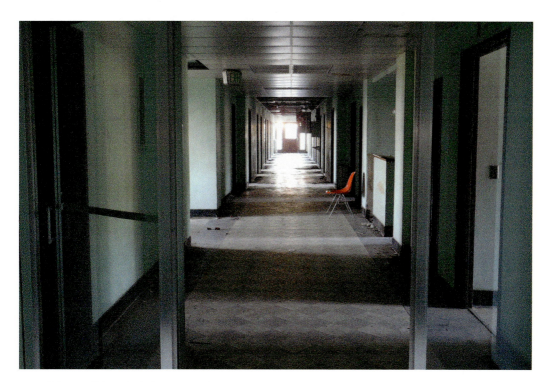

Arkansas Tuberculosis Sanatorium *[James Kirkendall]*

The Arkansas Tuberculosis Sanatorium plays second fiddle to no other location in my book. I jumped ten feet into the air when we received the "okay" to document the building. I have toured the main building of the Nyberg several times and have been heavily fascinated by its massive extending corridors. Just like the Verser Clinic Hospital, this location is filled with rich history and then some. It is still an operating campus and houses patients for the department of health and human services. However, there are still vacant floors that contain the original art deco architecture from when the Sanatorium was built. Don't worry, none of today's patients are housed anywhere near hazardous areas.

By researching DNA from Hungarian and Egyptian mummies, Scientists have determined tuberculosis has been present for thousands of years. In the late 1800s, Doctor Koch first discovered the bacteria that caused tuberculosis along with other diseases such as anthrax. One of the first Sanatoriums to be built in the United States was the Adirondack Cottage Sanitarium (little red). Dr. Edward Trudeau was inspired to build the one-room facility as he wanted to help his brother who was infected with the disease. Tuberculosis was once believed to be cured by rest alongside a milk and egg diet. In the worst cases, pneumothorax was used to collapse the lung. The disease wasn't picky on who it infected, though it seemed to target young people and

those who lived in areas of poverty. The National Tuberculosis Association's mission was to set a massive network of treatment facilities in the United States. At its peak, the Arkansas Tuberculosis Sanatorium stretched bigger than the town of Booneville. Its main hospital building was constructed by the order of a senator who had the disease himself. Senator Nyberg eventually died from tuberculosis at the campus. In 1909, the whole campus was completed by architects Haralson & Mott, Erhart & Eichenbaum. As the study of tuberculosis furthered, new antibiotics were invented and through the years the need for tuberculosis sanitariums dwindled. In the year 1973, the Arkansas Tuberculosis Sanatorium officially closed. The entire campus was listed on U.S National Register of Historic Places on October 5, 2006.

When you enter the main hospital building, it seems just like another building. The first floor has been renovated and is used for administrative offices. As you start moving up the never-ending flights of stairs you get a feeling that the place might be something more than an old building. The second through the fifth floors give you a certain sense of what the building might have been in its years of operation. The

Arkansas Tuberculosis Sanatorium *[James Kirkendall]*

rooms and halls are lined with cabinets, toilets, chairs, antique light fixtures, and plenty of hanging heaters. Looking down the hallways of checkered floors you see a very distant light through the window that looks as if a train were speeding down the hallway. Each floor has access to a kitchen area and meets up with an elevator shaft and nurses center. The fourth floor gives you the feeling of loneliness as if you were watching the movie *One Flew Over the Cuckoo's Nest*. At the end of the hallway stands imposing glass doors that lead to rooms with barred windows. This area was home to patients that were at risk of suicide. The basement was unusual as you would have to travel from the fifth floor to access a stairway to get there. When you get past all the holiday decorations stored in the basement area, you can see quite a bit of original items that were used in the past, such as surgery books, mattresses, gurneys, wheelchairs, and various medical equipment. I even found a vintage unopened can of juice left behind from the hospitals closing. Some say the basement was the hospital's morgue; however, some theories state the sanatorium never had a morgue at all.

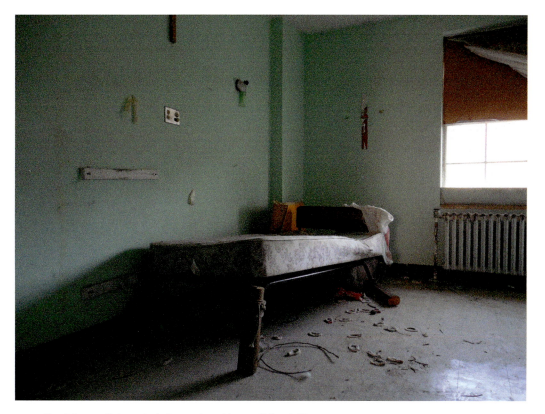

The Arkansas Tuberculosis Sanatorium *[James Kirkendall]*

Arkansas Tuberculosis Sanatorium
*[James Kirkendall]*

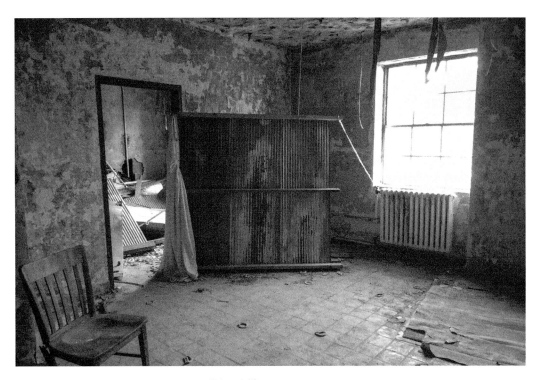

Arkansas Tuberculosis Sanatorium *[James Kirkendall]*

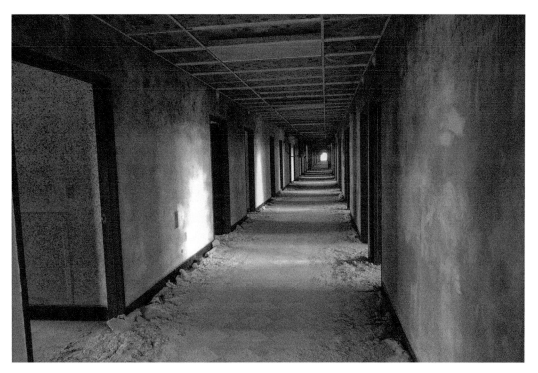

Arkansas Tuberculosis Sanatorium *[James Kirkendall]*

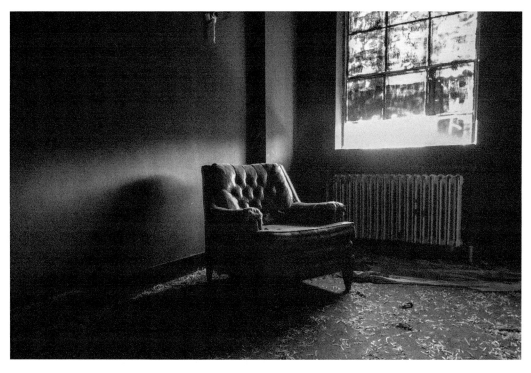

Arkansas Tuberculosis Sanatorium *[James Kirkendall]*

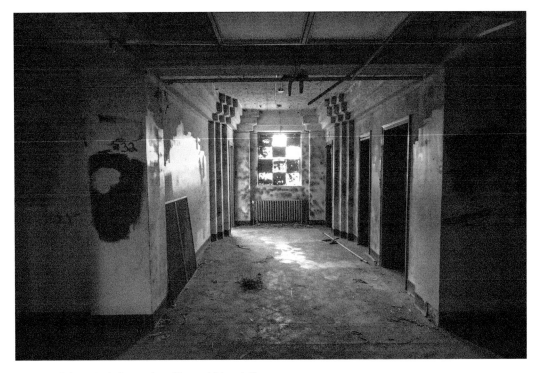

Arkansas Tuberculosis Sanatorium *[James Kirkendall]*

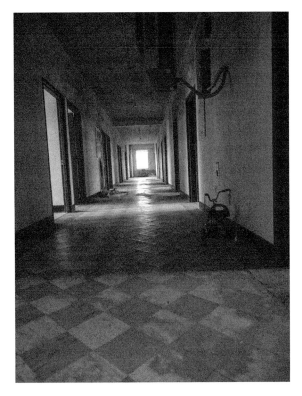

Arkansas Tuberculosis Sanatorium
*[James Kirkendall]*

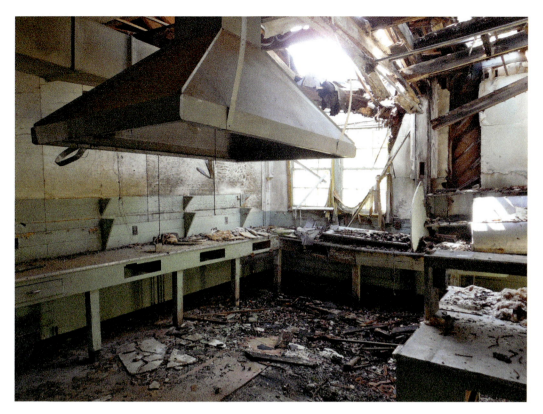

Fort Chaffee [James Kirkendall]

Last but not least on my list is the Fort Chaffee Field Hospital. There's nothing better than having a location to explore and document that's in your own backyard. The hospital was once an enormous campus that stretched acres upon acres located adjacent to the city of Fort Smith. The Fort Chaffee area is now the center for industry, redevelopment, and military operations. With its uncanny atmosphere, the hospital has been investigated by several local paranormal groups and individuals. Some people believe that it's been the housing grounds of spirits, demons, and ghosts.

The barrack- styled buildings opened in the year 1941. In its prime it was a city of its own with over 1,000 patient beds and even a theatre and bowling alley. After its days of being used as a hospital, it was the center for military training operations and was temporary housing for Cuban and Southeast Asian refugees. In 2011, an accidental fire destroyed most the hospital's complex. The general public believes that all of the buildings were destroyed. However, after you climb through rubble, shrubs, vines, and thorns and open the battered wooden doors, everything changes. With permission from the Fort Chaffee Redevelopment Authority, I have visited the location on several occasions and have discovered something new each time.

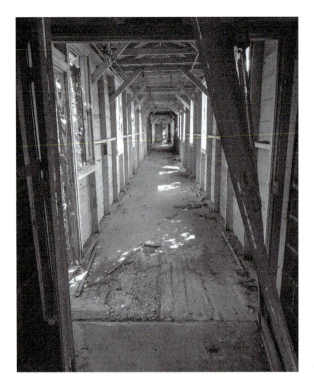

Fort Chaffee *[James Kirkendall]*

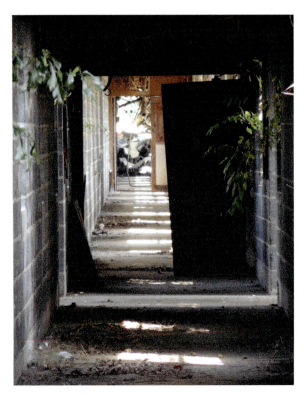

One of the corridors seems like it tunnels on for miles and miles. Though I wish I could have seen it before the fire, remnants of the hospital's former glory remain within its massive interconnecting hallways.

Originally, I had an interest in paranormal activity. However, when I started exploring new buildings, my interest shifted to the architecture and the items left behind. There is nothing wrong with ghost hunting, but I find it more fascinating to see things left behind that give me a glimpse of life in the past. I do believe at times some people confuse us as ghost hunters or just do not understand why we explore these places. I often hear, "Why do you take pictures of these old buildings?" Eventually, those same people understand that we photograph these places to trigger special memories made at those locations. I then hear the phrases such as, "Wow, that's really neat what you guys are doing," or "This team does wonders for this state."

Storyteller, photographer, preservationist, documentarian, historian, explorer; these are just a few of the different titles that define the photographers that make up "Abandoned Arkansas." Each member of the team adds their own unique experiences and specialties to the group, with mine being public relations, negotiating, and, of course, hospitals. We each have our own personal reasons for why we capture the history of these places. However, our joint mission is to preserve the memories for people and spread the word so that preservation and renovations might be made possible. We are taking our talents and furthering them to new possibilities. As photographers, we don't limit ourselves to only the aesthetic pleasure of the exterior. We want to capture everything. After all, it's about going to places the general public isn't allowed to view and taking preservation to a whole new perspective.

Fort Chaffee *[James Kirkendall]*

Fort Chaffee *[James Kirkendall]*

# EPILOGUE

Our common curiosity has led us to these historic places: once full of life, they are now now molding, crumbling, or sitting quietly in dust. Is the date they closed their doors the end of their story? We don't think so. We believe that the life that once pulsed behind the walls of these structures remains, an energy or spirit of sorts. Stepping through halls and doorways or walking through rooms and corridors, we hear the echoes of the past. Knowing our history and honoring what once was, while even helping to save a lovely old building when we can, is our goal. There are still so many places to explore.

More stories are waiting to be told. Any time there is an empty house, a lonely school, or a hospital that no longer hosts patients, the mystery and promise of adventure—and Abandoned Arkansas—will be there.

Fun Mountain, Mountain Home *[Michael Schwarz]*

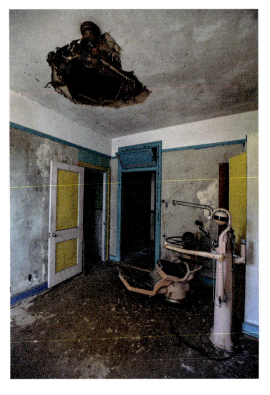

Desoto Hotel, Hot Springs *[Michael Schwarz]*

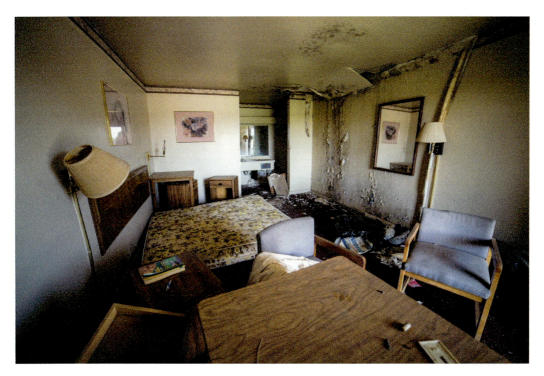

America's Best Inn, Pine Bluff, AR *[Michael Schwarz]*

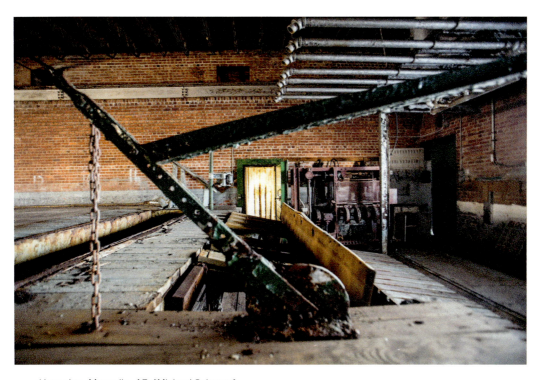

Home Ice, Magnolia, AR *[Michael Schwarz]*